How To
Draw and Paint
Animals

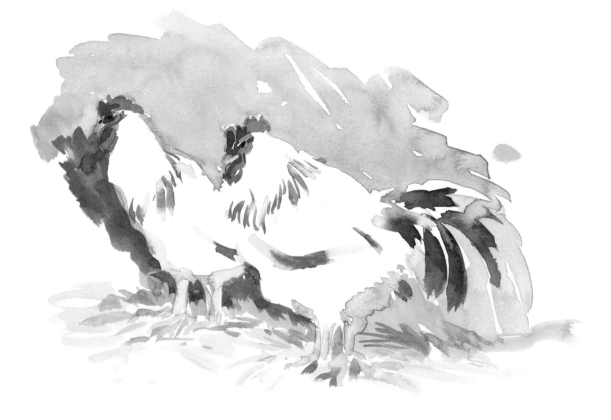

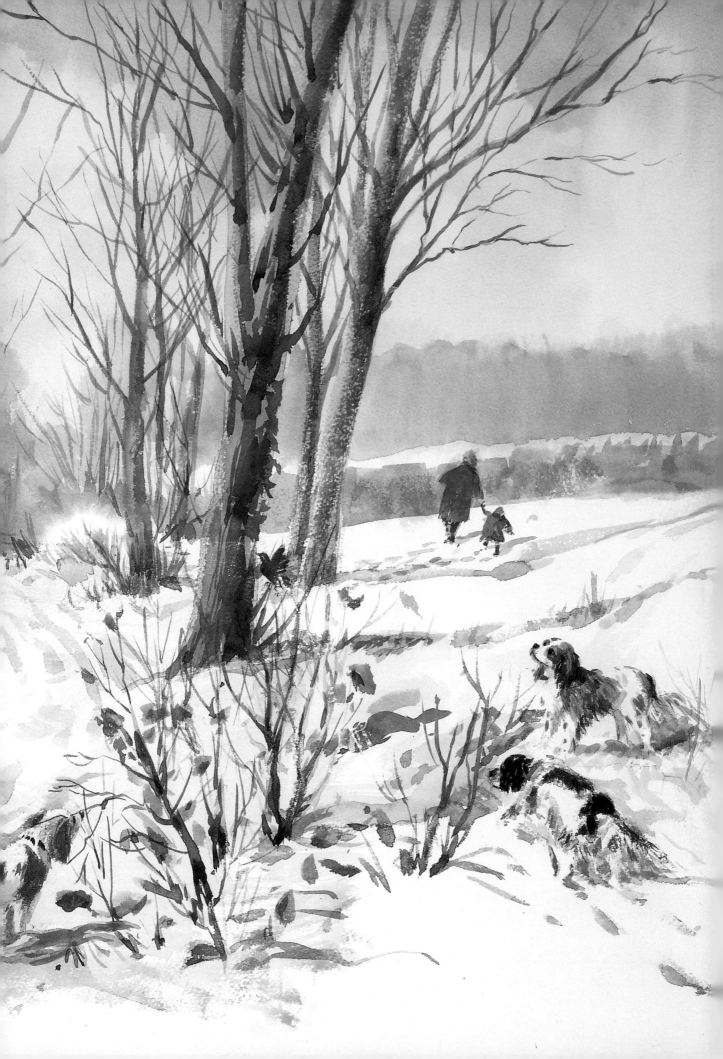

HOW TO
DRAW AND PAINT
ANIMALS

IN PENCIL, CHARCOAL, LINE
AND WATERCOLOUR

LINDA BIRCH

David & Charles

To the memory of my father Richard George Birch,
and all those who have helped me with this book.

A DAVID & CHARLES BOOK

First published in the UK in 1997

A catalogue record for this book is available from the British Library.

ISBN 0 7153 0499 2

Jacket picture of the author, Paul Judson
Book design by Les Dominey Design Company
and printed in Italy by Lego SpA
for David & Charles
Brunel House Newton Abbot Devon

CONTENTS

Introduction 6

Chapter 1 Materials and techniques 8

Chapter 2 Developing confidence 30

Chapter 3 Rendering texture 54

Chapter 4 Capturing movement 76

Chapter 5 Making pictures 92

Chapter 6 Questions and answers 124

Conclusion 127

Acknowledgements 127

Index 128

Introduction

'I only paint landscapes, animals are too difficult.'
'It's a specialist area, drawing animals.'
'Why do my sheep always look like white blobs?'

These are just some of the things people say when a friend asks them to draw or paint a portrait of a favourite pet, or when they decide to include an animal in a landscape painting.

Many people consider animal art to be a specialist area, the province of the gifted and knowledgeable few, but this is simply not true. Anyone can draw and paint animals if they want to. You do, however, need motivation and dogged persistence, and you must be prepared to accept that failure and mistakes are an important and inevitable part of the learning experience. Curiosity about animals and the way they behave is essential and should be combined with respect for them. Sentimentality is not a characteristic of the true animal artist.

This book has been written for the dedicated animal painter and also for those figurative artists who occasionally want to include animals in their compositions – pastoral landscape, for example, an interior scene which includes a pet, or a study of people at the zoo.

I have not set out to show you 'how to do it', instead I have concentrated on showing you what to 'look' for so that you learn how to 'see'. This ability to 'see' is the basis of all figurative art, whether landscape, still life, the human form, or animals. The approach is the same whatever the subject and seeing is achieved through observation and understanding what you observe.

I can't offer you many 'tricks', but I can show you ways of observing and methods of working that will help you to avoid mistakes. Above all, I hope that I can help you to develop the confidence to record and paint animals.

I start by considering the basic materials and how to choose the right medium for the subject. I don't suggest you have to learn a new medium, but I do suggest you consider trying different tools.

I discuss basic anatomy and look at simple methods of constructing form. One of the problems with drawing animals is the fact that they move about – they simply won't pose. In Chapter 4 I look at the ways in which you can make quick records, and learn to draw only what is relevant.

Chapter 5 looks at the processes involved in transforming a sketch or working drawing into a finished painting. Topics discussed include composing a picture, using perspective (both line and colour perspective) and using photographs as reference. There is also advice on finding your subjects, and working on location.

Chapter 6 takes the form of a question and answer section, providing a source of reference that you can turn to when you come across a particular problem.

This book is intended to inspire and inform you, but above all it is a reference tool, to be turned to when you have problems. After all, painting is about 'doing' it rather than wading through books about it.

Linda Birch

Materials and techniques

This book is concerned primarily with drawing in pencil and painting in watercolour because, in my opinion, these media are flexible and ideal for the subject, besides which they are my favourites. However, there are many other drawing media to choose from, many of which can also be combined with watercolour.

Selecting the appropriate medium and technique for a particular study is important. Suppose you wanted to make two drawings, one of an elephant and one of a mouse. The great difference in size obviously demands a different approach for each. While the fine line and delicacy of a pencil seems appropriate for a study of a mouse, a broader, bolder medium such as charcoal might be a better choice for the elephant. If you had never experimented with charcoal though you might be tempted to stick to pencil for both because that is what you know best.

In this section I describe and discuss briefly the properties of alternative drawing and painting media, concentrating on those that are water-based or can be combined easily with these. I hope this will encourage you to explore the exciting possibilities of different media.

GRAPHITE PENCILS

Graphite ('lead') pencils range from hard (the 'H' grades) to soft (the 'B' grades), the precise degree of hardness or softness designated by a code which is imprinted on the wooden casing. They run from 8H (the hardest) through 7H, 6H, 5H, 4H, 3H, 2H, H, HB, B, 2B, 3B, 4B, 5B, 6B, 7B, 8B to 9B, which is the softest. The 'H' grades are extremely hard and are used mainly by draughtspeople who need a crisp, precise line. The disadvantage of hard pencils is that they make an indentation in the paper which remains if the line is erased. However, you can sometimes exploit this characteristic: see, for example, the drawing of the mouse on p57.

For the artist, the most useful grades are those from HB to the softest B. However, I find the 2H useful for 'lining out' a drawing prior to using softer pencils for

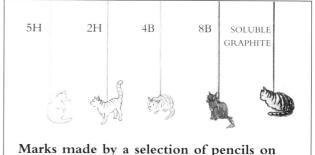

| 5H | 2H | 4B | 8B | SOLUBLE GRAPHITE |

Marks made by a selection of pencils on the same paper show the range of effects.

■ **The donkey was drawn in pencil on smooth white board. I used an HB for the outline and a 2B pencil to 'wash' in a light tone. The darkest tones were created with 5B and 9B pencils.**

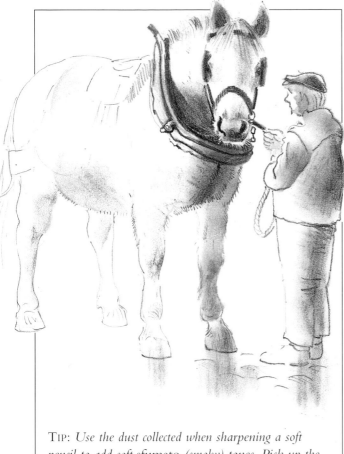

TIP: *Use the dust collected when sharpening a soft pencil to add soft* sfumato *(smoky) tones. Pick up the dust with a moist finger and rub into the drawing, protecting areas of the drawing with a mask of torn paper if necessary.*

SOLUBLE GRAPHITE PENCILS

Watersoluble pencils are particularly useful for sketching. They can be used wet or dry, or in a combination of both, and come in several grades, from medium to very soft. I particularly like the depth of tone which can be obtained with even the hardest grades: they give intense blacks but can also be used lightly to render fine lines. When you are drawing quickly it is useful to be able to use a single drawing tool; if you have to keep changing from one pencil to another you may find that your subject has moved. More importantly, changing tools breaks the flow from hand to eye, and interrupts concentration.

As their name suggests, the tones of soluble graphite pencils can be turned into washes by brushing them with water; when dry, the surface can be reworked with more pencil. I favour the scribble and spit method for working quickly outdoors! To soften tone, and to obtain *chiaroscuro* (an Italian word meaning 'light and dark') or subtle gradations of tones I scribble with my pencil, accenting some areas by blending them with a moistened finger. This enables me to work quickly with the minimum of tools. These pencils should be kept sharp in the same way as conventional graphite pencils.

shading. For sketching, the 2B is a good all-rounder, giving fine lines when required, and strong darks when applied with some pressure. I use the 2H, 2B, 5B and 9B when drawing and shading in pencil; the softest (the 9B) gives deep, velvety black marks.

Soft pencils need to be sharpened more often than harder grades of pencil. For this I would recommend using a sharp craft knife. Pencil sharpeners can break the tip of the lead, and a knife gives you more control over the shape of the drawing point. I use a point when drawing outline, and a chisel tip when shading. Of course, it does not always work out like that. When working outdoors at speed I generally use a 2B pencil only. I start with a sharp pencil, and as it wears down it can be used on its side to shade with. For best results, however, keep your pencils sharp or well chiselled according to your need. More drawings fail because the pencil simply was not sharp, than because of bad drawing.

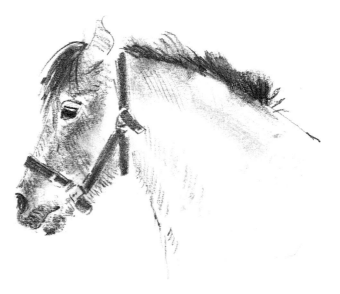

■ **This sketch of a pony's head was worked with a watersoluble graphite pencil, using it both dry and wet to render tone.**

CHARCOAL

Charcoal is sold as thin or thick sticks, or in a compressed, pencil form. It is ideal for large-scale work – which may be why many new artists, being inhibited, avoid using it unless asked to do so in a class. It is messy (another reason for not wanting to use it) and is not easily erased. The temptation is to try and use it like a pencil and that is where things go wrong. Certainly charcoal *can* be used in a bold, linear manner, but it is best when used as a tonal medium on a large scale. It is capable of the most subtle and sensitive transitions from light to dark and is a great teacher of tonal understanding. When teaching new painters I always set them exercises in charcoal before approaching paint. It displays its best properties on a smoother paper, although Georges Seurat (1859–1891) did some splendid drawings on heavily textured paper. Use it in conjunction with a soft 'putty' eraser, not to eradicate mistakes, but to create soft tones and to lift out light areas.

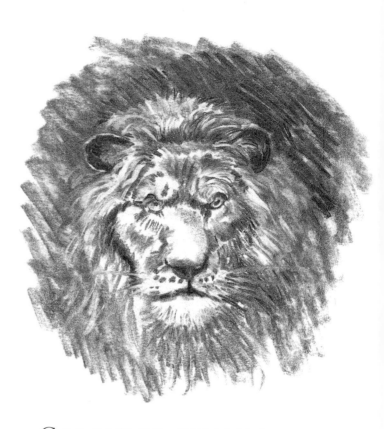

■ **Above right: Charcoal can be used as a tonal medium and is capable of a wide range of effects. It can be worked crisply or softly, while pressure produces velvety black marks. The lion was worked from light to dark with a short stick of charcoal. A small twist of putty rubber and a torchon stump were used to lift out the mane and whiskers.**

COLOURED PENCILS

I often combine coloured pencils with watercolour. They can be used to add texture to a flat wash, or to intensify or lighten tones without adding another wash. Coloured pencils used on their own are useful for detailed work. They can be built up gradually on almost any paper surface, although smooth cartridge is especially suitable, and they give you a great deal of control, unlike watercolour which can be unpredictable. I have noticed that school students seem to enjoy using them for this reason.

Buy good quality coloured pencils from an art store. Unless you can afford a very large box it is better to put together a set of colours by buying them singly. The boxed sets often contain a limited range of unsuitable and mostly primary colours. If you make your own selection you can choose colours that suit your needs. I find the tertiary colours (or neutrals) particularly useful – the greys, olives and buff colours.

■ **For this study of my kitten I used watercolour pencils, building up the form gradually by wetting the ends of the pencils with water. Dry colour was added on top to produce texture and detail.**

■ This humming bird was created in dry coloured pencils on cartridge paper; the colours can be built up gradually in a controlled method, the lightest being applied first. The wings were smudged slightly in order to indicate the blur caused by fast movement.

■ Below: The lamb was worked in watercolour with texture added using coloured pencil. Make sure the painting is dry before working pencil on top.

TIP: *White coloured pencil is useful for describing whiskers against dark fur or hair.*

As with graphite pencils, these should always be used sharp. I keep mine alongside my watercolours, ready to use when needed.

I usually work with watersoluble or 'watercolour' pencils which are blendable with water, although I often use them dry. This gives me the choice of two media in one tool – coloured pencil and painting pencil. Watersoluble coloured pencils can be dissolved with water to create thin washes: I like to use them on top of watercolour by applying the dry pencil and then wetting the pencil mark with a brush to make a wash. Alternatively, the tip of the pencil can be made wet and used to rub colour onto the paper. Colour can also be taken from the tip of the pencil with a wet brush and applied to the paper. Watercolour pencils do not give the broad, clear, intense washes that watercolour paint gives, and a 'pencil painting' can look meagre by comparison with true water-colour, but on smaller paintings it is possible to achieve detail and depth of colour.

Watercolour pencils are thought by some to be a useful medium for holiday working, being easily transported and clean to use. You should, however, be aware of their limitations – in particular they are not suitable for making rapid, full-colour sketches because the technique is painstaking and therefore quite time-consuming.

Watercolour pencils are made by several firms. I suggest you buy those that feel softest as they give better depth of colour and are more responsive.

WATERCOLOUR CRAYONS

These are wax-bound stick colours that can be used dry as crayons, or wetted and used as watercolours. They are similar to watercolour pencils but offer a broader mark. The colour range is limited but the colours can be mixed and blended on the surface of the paper. They should be used on heavy papers, and can be used in a broad manner similar to pastel. Try breaking the crayons into short pieces and applying the colour lengthwise. Colour can be scribbled on and dampened, as in this case, or the tip of the crayon can be moistened; also crayon shavings can be dissolved in a little water to make a wash. In addition, watercolour crayons can be used dry on top of watercolour.

■ **Above: Neocolor watercolour crayons were used to make this head-on study of a cow on watercolour paper.**

PEN AND INK

Pen and ink can be used to render fine detail or more boldly and fluently to capture a fleeting movement, the character of the line depending on the type of pen. It can be combined with watercolour: if the pen is used first, the result is known as line and wash; if the painting is completed and the line is added on top, it is called wash and line.

DIP PENS Simple pens which are charged by dipping into ink or watercolour; the line produced is variable and full of character and they are the first choice of many artists. Their drawbacks are accidental blotting, and the nibs becoming blocked with paper particles. When buying drawing nibs, ask for them by name, or you may be given calligraphy nibs by mistake.

FOUNTAIN PENS Useful if you have nothing else to draw with; however, the nibs are not suited to drawing as they do not flex well, although they can produce flowing lines and decisive marks.

INK For dip pens you can use Indian ink, or a drawing ink in colours from black to white with a good range of colours between. I find black or dark brown the most useful. Fountain pens need to be filled with fountain pen ink (*not* Indian or drawing ink).

■ **Below: I used dip pen and ink, with hatched lines for the shadows and textural marks for 'colour' in this drawing of a bull and dog. I chose black Indian ink and a 303 Gillot drawing nib. The outlines were drawn first in pencil and rubbed out when the ink was dry.**

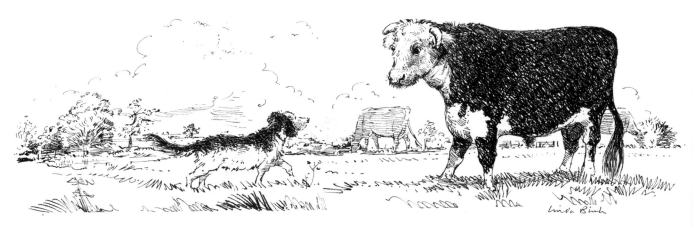

TECHNICAL PENS These were designed for draughtsmen and graphic designers, but they are also used by fine artists. They have a stylus rather than a nib, and most are bought with ink-filled cartridges. They produce a fine line of a constant width and are available in a range of thicknesses. They lack the quirkiness that gives dip pens their character, but are less messy to use!

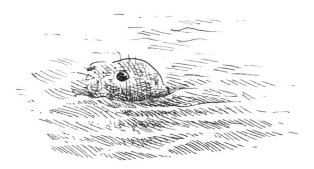

■ **Above: Technical pens are a good sketching tool, which enabled me to make a quick drawing of this seal's head, using cross-hatching for the shadows.**

FELT-TIP PENS These have come a long way from being simply children's drawing pens. They can be bought in a wide range of colours, some of them very subtle, and can be used on their own or on top of watercolours. Broad or fine tips are available (sometimes double-ended), and some can be diluted with water to create a half tone. They are ideal for sketching and can be used to capture subjects quickly and simply. If the pen is watersoluble you can use a licked finger to smudge the ink to create a satisfactory half-tone. I was once sitting on a friend's balcony in Canada when a little humming bird came and hovered at a bush below me. I managed to draw it in a soluble pen, but soon realized that I needed water to achieve the blur of its fast-beating wings. My dilemma was that I had a brush to hand but there was no water, and if I moved it would fly off. The answer, however, lay close by, and I completed the study in gin and tonic!

■ **Below: Coloured felt-tip pens with a broad chisel tip have been added on top of a lightly painted watercolour in this illustration of sheep on a moor. All the soft colouring on the path was done with felt-tip pen, as were the sheep and the vegetation.**

■ Above: Felt-tip pens make good sketching pens and were ideal for illustrating these lambs. If they are watersoluble they can be wetted to create half-tones. The cheaper brands may not be lightfast, so check this before starting a picture that you might want to keep.

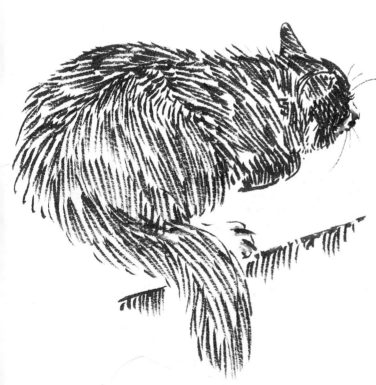

BRUSHPENS Brushpens resemble pens, but they have a fibre brush-type tip; they can be used to create expressive marks similar to those made by a true brush. Some are double ended with a pen point on the other end. They are useful for sketching.

BALLPOINT PENS Useful for sketching, but they are inclined to blob when least expected. They are best for line drawing.

HOME-MADE PENS These pens can be created from cocktail sticks, twigs, feathers (quills) and bamboo sticks. Although they do not carry much ink compared with nibbed pens, they do make good expressive marks. Bamboo pens and quills can be made by cutting a diagonal slice off the end. Quills can be sharpened to a point by further side cuts.

■ Left: The form and the texture of this long-haired cat are conveyed well by strokes of a brushpen. They can be moistened to make half-tones.

■ Left: Twigs are an interesting tool to use, and can flex a little. Let the pen reveal its linear qualities, rather than imposing your own style on it. Spots and smudges should be allowed to remain, where practicable; they can add life to the drawing.

■ Below right: A bamboo pen used with Indian ink gave strength and bulk to the gorilla's form, its lines being firm and heavy. The pen was made from a piece of bamboo as thick as a small finger. Bamboo pens need to be constantly charged with ink, so are more suited to studio work than outside.

■ Above: This tiger face was drawn with the quill end of a dried and hardened feather. The original 'pen', a quill gives a sensitive variable line.

SCRAPERBOARD

This is commercially prepared thin card coated with a solid chalky layer, overlaid with black or white ink. The image is scraped or scratched out from the black surface; white card can be coated with ink of any colour, allowed to dry, and the image scraped into it. The effect is similar to a woodcut but it produces finer lines, rather like a steel engraving (and is an easier process). Specially designed scrapers are available or you can use an old nail or a small, sharp blade. Wood-engraving tools can be used but are rather expensive. The great English illustrator Charles Tunnicliffe (1901–79), famous for his studies of animals and birds, used scraperboard in his later career. Scraperboard kits (board and tools) are available in art stores.

WATERCOLOURS

Watercolour is available in two forms: in tubes in which the colour is soft and moist, or as 'pans' of solid colour. There are two grades of paint: artist's colours and student's colours. Artist's quality paints (tubes or pans) are more expensive because they contain a higher proportion of pigment to filler (bulking material), and are more finely ground. Student's colours are a cheaper range; they contain a higher proportion of filler to pigment, are less finely ground, and are generally available in a more limited range of colours. Student's colours are satisfactory paints, but some colours are more difficult to release (the colour does not transfer to the brush easily).

The watercolour paintings in this book were produced with a range of paints that lies between artist's and student's quality colours (called 'Van Gogh', they are made by Royal Dutch Talens). They have the consistency and feel of artist's colours and almost the same lightfastness, but they retail at the same price as student's quality paints. They are available in tubes and pans, in boxed sets or they can be purchased singly.

Watercolour has unique qualities. The transparency and sensitivity of its colour have always been admired and sought after by artists. It is ideal for animal painting because its immediacy matches the liveliness of the subject: it can capture the fleeting quality of subjects better than almost any other medium.

Watercolour is applied to the support in the form of a wash – that is, paint diluted with water. The skill of watercolour painting lies in the ability to control these washes. And, as I know, there is plenty of opportunity for things to go wrong! Typically, problems arise when too much paint has been laid over other colour, creating a muddy effect. Also, because it is difficult to correct mistakes, you may be too timid and use too little paint, resulting in a niggardly painting that is a travesty of a watercolour. A watercolour should look unlaboured, even though we know it is far from easy to do!

AVOIDING PROBLEMS

The following tips will help you to avoid the major problems:

- Choose a suitable paper for your subject.
- Use large brushes wherever you can, saving small ones for detail only.
- Do not try to lay more than three washes over each other.
- Limit the number of colours you use to four or five at most, so that they will relate to each other.
- Be bold with colour. Watercolour dries lighter, and you will be closer to the colour you want if you exaggerate.
- Save any detail until the last stage of the painting. This will stop you fiddling.
- Work from light to dark, and from the back of the picture to the front. This means that the painting

■ **The grey Bockingford watercolour paper provides a unifying colour which holds the image of these wading horses together.**

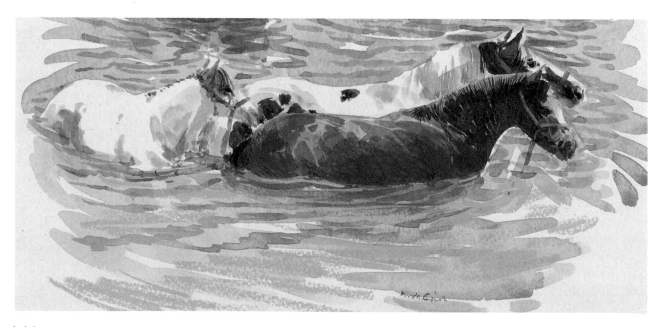

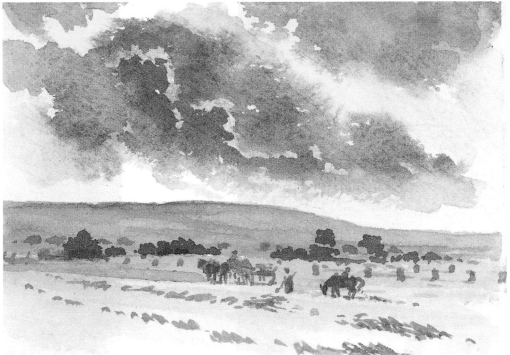

■ **For this harvest landscape in water-colour, a wash of diluted yellow ink was laid on top of other colours to create some interesting effects and pull the colours together. The middle of the painting has been left showing the original colour.**

is worked from top to bottom. If, for example, you are painting a landscape, lay in the sky first. Next deal with the middle distance, and lastly the foreground. Animal subjects should be painted according to their location in the composition.

RESCUING WATERCOLOURS

I try to give my students confidence and an important aspect of this is knowing how to put things right when they have gone wrong.

■ Muddy pictures can sometimes be saved by washing them under a slow running tap, gently rubbing off the excess paint with a large, soft

brush. Allow the paper to dry and then repaint the parts with which you were dissatisfied. This method depends on the paper being fairly robust: it should be at least 140lb (300gsm) in weight.

■ Under-painted or timidly worked paintings can be improved by adding pen and ink. This strengthens and emphasizes the drawing and distracts attention from the painting.

■ You can apply pastel or coloured pencil over watercolour to rejuvenate the colour and add texture to the painting.

■ A thin wash of yellow drawing ink over the whole picture will pull disparate colours together.

■ **These lambs were painted on the spot, so had to be recorded quickly. The smooth paper enabled the brush strokes to be applied easily.**

OTHER WATERCOLOUR MATERIALS

MASKING FLUID This liquid latex is used to paint over areas that need to be protected or 'masked' against subsequent washes of colour. Use a pen or cheap brush to apply the fluid. When the painting is finished, the masking fluid can be rubbed off with a tissue or soft eraser. Wash the brush in soapy water.

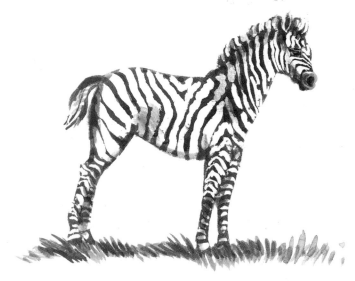

■ **Above: Masking fluid was applied to the areas of the lightly drawn zebra foal which were to be left white. When it was dry, a dark wash was applied over the whole form, together with those parts depicting dark shadows and details. When the paint was dry, the latex was rubbed off gently, revealing the areas beneath which were still white. The shadows needed on these white areas and all further final details were then added.**

OX GALL This increases the wetting and flow of watercolour paints.

GUM ARABIC The binding medium of watercolour. Extra gum arabic can be added to a wash to increase the flow and brilliancy of the paint. It is useful for large washes.

WAX CANDLES These can be used to make a 'resist' texture on watercolour, a process which is particularly useful for foreground textures such as walls or stonework. I find birthday candles a useful size to work with. The wax cannot be removed and becomes part of the final picture surface.

SALT Sprinkle salt onto a drying wash to create granular effects. You will need to experiment to find the right stage in the drying process and to mix a wash of the right strength. Shake off the salt when it is completely dry.

NATURAL SPONGES These are a useful addition to your workbox; they can be used to mop out clouds and lift areas of paint, and are also useful for making certain textures. For example, dip the sponge in clean water and then squeeze it until nearly dry; then dab an area of wet wash to create a dappled texture. Small natural sponges can be bought at art stores.

■ **Below: A natural sponge was used on this seal. The mix needs to be fairly strong with very little water to create the required texture.**

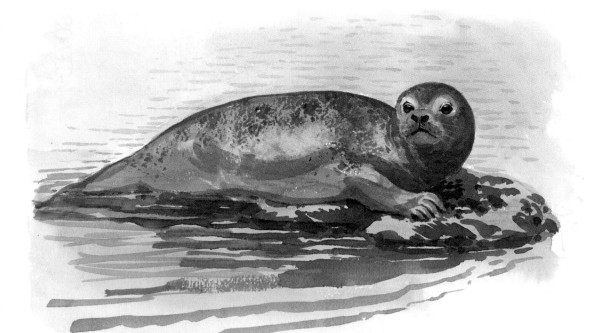

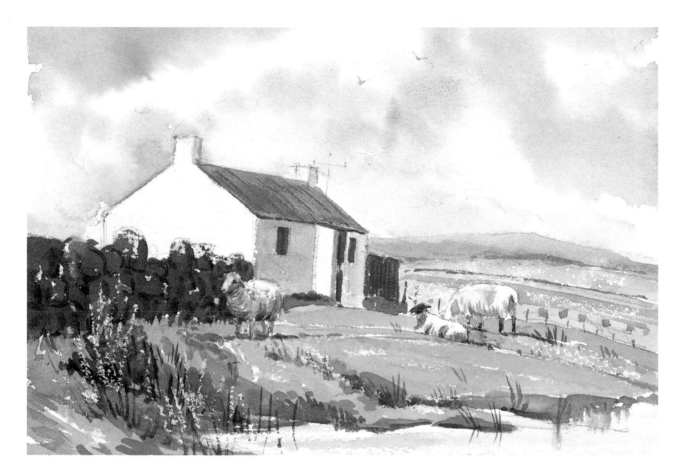

■ **Above: Wax resist can be used to give sparkle and texture to a watercolour. A small candle was rubbed across areas in this picture of some sheep and a croft before starting to paint – you need to plan this carefully. As the washes are painted on, the wax resists the water, giving a broken effect. However, be aware that wax cannot be removed.**

■ **Below: Gouache was used to paint this pony, building up the colour quite thickly from dark to light.**

GOUACHE

This is an opaque form of watercolour. With pure transparent watercolour the lightest tone is the white of the paper, and colours are lightened by adding more water to the wash. With gouache, however, you can add white to a colour to achieve a lighter tone. Moreover, because of its opacity, dark tones can be over-painted with light tones, so you can work from dark to light. Thus you can use gouache to add detail to a watercolour, although make sure that you do not jeopardize the airy transparency of pure watercolour.

Gouache can be varnished if necessary, because the colours tend to be a little chalky when dry. It should be placed under glass in the same way as a watercolour, when framing.

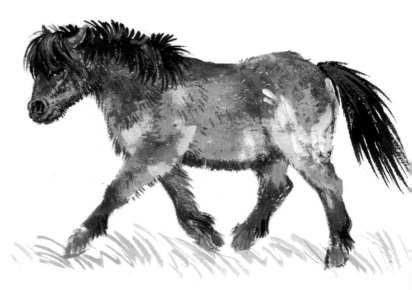

PASTELS

There are four types of pastel. Hard and soft pastels consist of dry, powdered pigment mixed with just enough gum (arabic or tragacanth) to bind and harden it; the mixture is pressed into moulds and dried into sticks. Hard pastel contains a larger proportion of binder than soft pastel. Pastel pencils are a pencil form of these. Oil pastels are bound with a mixture of oils and waxes.

All these pastels can be used on their own, or in combination with many other media (although oil pastel is not compatible with the other pastels). All pastels can be used on watercolour paintings to add texture and vibrancy to the paint surface, and can be used to 'rescue' a watercolour that has gone flat.

HARD AND SOFT PASTELS

The harder types of pastel (including conté crayons) are suited to a linear, hatching method of building up colour; soft (or chalk) pastels can be used for more painterly techniques.

The traditional ground for pastels is a tinted paper, sometimes called Ingres (after the great French painter Jean Dominique Ingres, 1780–1867). Tinted papers are available in a wide range of colours and shades. Choose a colour that relates to the subject in some way, either to harmonize or contrast with the main colours: the tone of the paper can be allowed to show through the pastel, and becomes part of the painting.

You can, however, use white paper if you want and a smooth paper will work well with pastel. Other surfaces suitable for pastel are watercolour paper, old cardboard and fine sandpaper. Special pastel boards offer a sympathetic, slightly abrasive surface.

When a pastel stick is rubbed on paper, the friction causes powder to be rubbed off and deposited on the surface; the minute particles in fact stand upright. The method of working in pastels depends on the subject matter. The colours are opaque so you can work from dark to light, but if you are creating a pale picture you should start with the light colours.

The colours cannot be mixed before you use them, which means that you must have a wide range

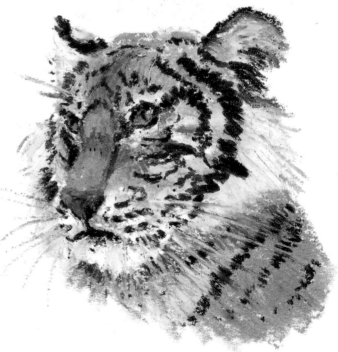

■ **Above: The strikingly marked coat of this tiger was made in oil pastel on thick cartridge paper. I worked the colour from light to dark as there were more light areas in the image, and smudged the colour where necessary using a torchon.**

■ **Left: Soft pastels were used for this golden chicken, that almost seems to glow with colour. Setting it against a mauve-blue paper (the complementary colour to the subject) gives the colour intensity maximum contrast.**

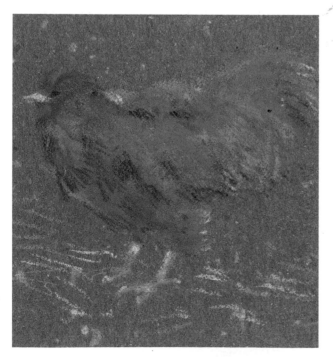

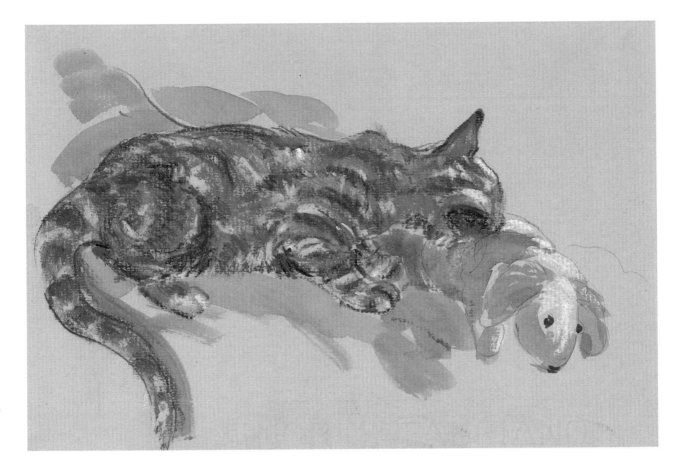

■ **For this study of a young cat I used oil pastel on top of watercolour to create an interesting textural surface. Oil or soft pastel can also be used to 'rescue' a watercolour which has gone flat.**

of pastels in different hues and tones. Colour can be laid on in regular hatching lines, building up a surface gradually by crossing lines of colour; the French artist Edgar Degas (1834–1917) used this technique for his *Bathing Nude* pictures. The harder you press with pastels the more vibrant the colour becomes, and you can use this quality to create passages of heavy, emphatic colour which can be contrasted with lighter areas to give a varied surface.

A torchon stump, or tortillon (a tightly rolled stick of paper), or cottonwool buds can be used to blend colours. However, don't be tempted to do too much blending or to overwork pastel: once the paper surface becomes 'filled' or rubbed you may flatten the particles of colour, causing the picture to look somewhat bland and flat.

Fixative can also flatten a picture. The spray should be applied from a distance of at least an arm's

length, and don't overspray. Many pastel artists avoid spraying their paintings at all.

Pastels are among the most durable of all media, but they are easily damaged and have to be protected under glass. Have them framed when you can to preserve them. When storing them unframed, avoid laying sheets of paper on top of them, but if you must, lay a sheet of tissue paper between the sheets.

PASTEL PENCILS
These are useful for linear work and detail. The results can appear a little 'mean' if used in any other than a linear technique, as the size of the drawing point makes it difficult to produce large areas of colour.

OIL PASTELS
Oil pastels can be used on almost any surface including drawing, watercolour or pastel papers. The colours can be mixed directly on the paper, or blended with a cottonwool bud, soft tissue or torchon. They can also be blended with turpentine and used in a more painterly way. Being opaque, they can be worked from dark to light or light to dark, and white can be used to lighten colours.

BRUSHES, JARS AND PALETTES

It is easy to be intimidated by other people's art equipment. I used to think that the more brushes one had, the better the painting, but this is not true. You need only four brushes for watercolour painting, and even three would do. However, a 'mop' is absolutely essential: this is a large, soft-haired brush designed for making washes on large areas such as skies – an old shaving brush will make a good wash brush.

A medium-sized brush is also necessary. Nothing feels quite like sable, but if funds do not allow, synthetic brushes are almost as good. Choose a rounded brush in size 6, 7 or 8.

Lastly, you will need a small brush for detail. Again, a sable is best, but a man-made fibre will do almost as well. Choose a size 2 or 3.

With these three you can probably produce all the effects you require, and with care they will last for years. So, do not leave them up to their necks in water for long periods – in fact, treat them as you would your own hair: wash them thoroughly in clean water, and if you use ink or oils you may have to wash them with soap and water. Do not use very hot water to clean them.

A square-ended synthetic brush is useful for buildings, and to depict manes and tails. Squirrel-hair brushes have a soft point and are useful for twigs and branches, and for long hair or fur.

Chinese brushes have similar qualities to squirrel brushes, but are cheaper; they come in all sizes and are mounted on bamboo handles. They tend to shed hairs, but I find this is not a problem because the hairs drop off the painting when dry without leaving a mark on the paper.

Use the largest jar you can find to hold water, and preferably two. Watercolours become muddied if you use dirty water so change your water often.

When mixing colours do not rely solely on the lid of your paintbox, but use a large white plate or plastic board to mix on as well. A mixing area which is too small leads to problems: colours accidentally mingle, creating muddy mixes, and you may not mix enough paint, resulting in a thinly painted picture, or one that is patchy because you have had to remix colours.

Tissues are invaluable for mopping up spills, lifting wet areas quickly or even creating cloud effects. I use toilet roll rather than kitchen roll because the latter's textured surface leaves dimpled marks. After laying in the medium colour on an animal with a short shiny coat such as a horse, try rolling a small 'cigar' of tissue to lift out the highlights.

PAPER

The surface, or ground, on which you draw is as important as the medium you use. Paper used for a watercolour painting is often referred to as the 'support'.

DRAWING PAPER

The most obvious paper for drawing on is *cartridge* because it is designed specifically as an all-purpose drawing paper. It is available as single sheets, in bound books, or in pads which may be spiral-bound or gummed. Cartridge paper is fairly smooth and will accept pencil, pen, crayon, pastel and even light washes of watercolour. I suggest you choose the thicker, heavier weights of cartridge paper because it is more robust and pleasing to use than lighter papers; you can work vigorously in pen or pencil without going through it!

Other drawing surfaces include thin *copy paper* and specialist papers such as *rice paper*. *Bristol board* is a smooth white board ideal for any line work such as pen and ink, and pencil; there are cheaper versions of this board (including one I use called Ivorex).

Pastel paper makes a lovely drawing surface, especially for pen and ink. Ingres pastel paper for example has a 'laid' surface, a ribbed texture which is imprinted into the paper by the wire screen used in the manufacturing process. *Watercolour paper* can be used for drawing, too – choose the smooth HP (hot pressed) or Not surface papers for pencil work. Rough watercolour paper is good for crayon or charcoal.

WATERCOLOUR PAPER

Choosing the right paper is particularly important for watercolour, because the nature of the surface will affect the appearance of the final image. You need to get to know the different types of paper available, and you should make a point of deliberately changing the paper you use from time to time.

> TIP: *When buying a sketchbook, choose one with thick cartridge paper, which can be used with watercolour if necessary. If you did your best painting in your sketchbook, it would be disappointing if the paper cockled (buckled) because it was too thin.*

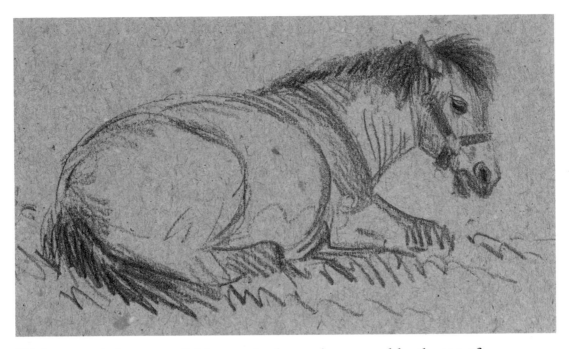

■ **The rugged character of this moorland pony is conveyed by the use of soft pencil on pastel paper.**

The best quality and most expensive papers are rag papers, made from linen rag, which produces a soft absorbent surface, ideal for wet-on-wet techniques. Hand-made papers are generally superior in quality to the machine-made papers. They are sold as single sheets and have rough 'deckle' edges. Hold the paper up to the light to read the watermarked name of the maker – this is the 'right', or top (painting) side of the paper, although these days nearly all papers are suitable for painting on both sides.

Watercolour paper is sold by the sheet or in pads (spiral bound or tear-out). Gummed blocks have a small unglued area into which you can insert a flat blade to slice off a sheet when a painting is finished. Pads or blocks are convenient, though sheets allow you to work on a larger scale.

The stated weight of a watercolour paper tells you how thick it is. Weight is based on how many pounds of paper are needed to make a ream (500 sheets) or how many grammes a square metre would weigh (gsm). The heaviest papers are 300lb to the ream (or 638gsm) and 400lb (850gsm); a mediumweight paper would be 140lb (300gsm); and lightweight papers are 70lb (174gsm) and 90lb (190gsm). The heavier the paper the more expensive it is. Buy the best paper you can afford, and if this is only lighter papers, then they will need to be stretched if you intend to use heavy washes.

Watercolour paper has three main types of surface, and these affect the transparency of the paint, its absorption and also its working qualities.

Rough paper has a deeply textured and irregular surface which makes the colour appear to sparkle. It is better at conveying broad effects than detail, although the effects can be crude.

Not, or *Cold-pressed (CP) paper* is smoother with a slight 'tooth' (texture). It is suitable for most watercolour techniques, including wet-on-wet: an ideal support for a first-time watercolour painter.

Hot-pressed (HP) paper has a smooth surface. It is useful for fine details and gives interesting effects when used for wetter techniques. The results are very different from those achieved on a rough surface.

Other surfaces suitable for watercolour and gouache include mounting board (thin white or coloured card), coloured pastel papers and cartridge, which must be stretched.

TIP: *If you are not sure which is the right watercolour surface for you, write to the manufacturer for a sample swatch of different types of paper. These are free and can be tried before buying. Look out for bargain offers of different watercolour papers in your art shop.*

1

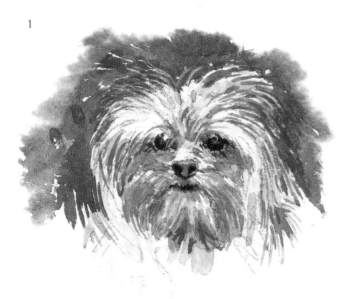

■ **Left: The dog was painted on three different types of paper to demonstrate the effect paper has on a watercolour painting. The papers used were:**

1. Artistico rough: a coarse-textured paper suitable for broad effects. Its uneven surface gives watercolours a special sparkle.

2. Waterford Not: a general-purpose, slightly textured paper favoured by beginners.

3. Artistico HP (hot pressed): a smooth paper, useful for detailed work.

2

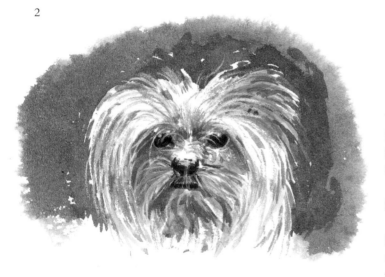

STRETCHING PAPER
Stretching paper prevents it from cockling (buckling) and is necessary for all thin paper.

You will need:
■ a drawing board
■ a roll of gummed paper tape
■ a sheet of paper – cartridge, pastel paper, 70lb (174gsm), 90lb (190gsm) watercolour paper
■ scissors

Soak the sheet of paper in a bath of clean water until it is soft (or use a natural sponge to apply water evenly over the entire surface). The paper should be uniformly damp, but not soaking. Meanwhile, cut tape into strips a little longer than the edges of the paper. Lift the paper gently, allowing the water to drain off, and place it on a tiled surface to drain further. Lay it flat on the board, blotting the surface gently. Dip the strips of tape in water and place the tape along the edges of the paper, so that it is half on the paper and half on the board. Leave to dry flat.

When dry, the surface is as tight as a drumskin. The painting is done on the paper while it is still attached to the board, and when it is finished the paper is removed by cutting around the edge under the tape with a knife. The taped edge provides a useful guide for the framer when mounting the work before framing.

3

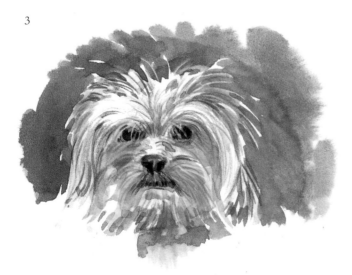

COLOUR

Colour media such as coloured pencils, watercolour crayons, watercolour paints, gouache and pastels are all valuable for drawing and painting animals. They enable you to describe, at a stroke, not only the form and action of the animal, but also its local colour (that is, the actual colour of the fur, skin or feathers). It is important to have a good understanding of the way colour works, to ensure that the colours you use work well together and contribute effectively to the success of the painting.

Watercolour differs from other media in that it is a translucent medium and therefore must be worked from light to dark. All the other colour media used in this book are opaque and can generally be worked by being built up either from light to dark or from dark to light.

Colour has a tonal value which is important to consider when working. Yellow, for instance, is a lighter tone than purple; though a deep yellow ochre may be deeper in tone than a pale mauve.

Some colours seem to jump towards you on the picture plane; these (generally reds, oranges and yellows) are defined as warm colours. 'Cool' colours, such as blues and greens, generally appear to recede in a painting.

Colours do not stand independently in a drawing or painting; they always react to light or to adjacent colours. To be able to understand and exploit this, it is useful to consider the basics of colour theory.

COLOUR WHEEL

This is a convenient arrangement of the spectrum colours in a circle. The three primary colours; red, yellow and blue are placed at equal distances from

each other. Their mixtures create the secondary colours; orange (red plus yellow), purple (red plus blue) and green (blue plus yellow). It requires specific compatible pigments to make some colours, and on the next page is a colour wheel based on the colours I have in my paintbox.

Colours which are opposite each other on the wheel are described as being complementary to each other, or complementary pairs. Complementaries create the maximum contrast and impact in a picture. The complement of a primary is a secondary, thus the complementary of blue is orange, of yellow it is purple, and red has green as its complementary.

To achieve the maximum complementary effect you must vary the tone of one of the colours; any lightened or darkened version of the colour will have the same effect when placed next to its complementary. For example, red and green are opposites on the wheel, and therefore they are complementary. If you use pink (pale red) next to a dark green in your painting you will also be exploiting the effect of complementary colours.

An understanding of the complementary relationship will help you to use colour effectively, adding zest to a painting by introducing a touch of the complementary into the shadows – a little mauve into the shadows on a golden-coloured animal, for example.

> TIP: *To make grey, mix any primary colour with its complementary.*

MADDER LAKE AND
YELLOW OCHRE

CERULEAN BLUE AND
MADDER LAKE

YELLOW OCHRE AND INDIGO

A DULL BROWN ORANGE

GREY PURPLE

OLIVE

■ **Primary colours: azo yellow, permanent red deep and French ultramarine can be mixed to produce a good range of most colours, though not every hue. The colour of the primaries affects the colour mixes: for example, mixing madder lake and yellow ochre will result in orange, but it is a less vibrant orange than a mix of azo yellow and permanent red deep.**

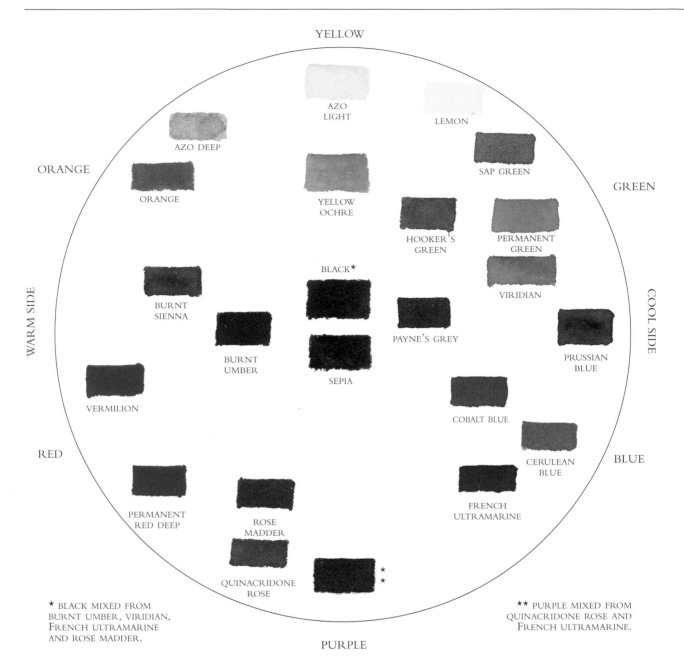

YELLOW

AZO
LIGHT

LEMON

AZO DEEP

SAP GREEN

ORANGE

ORANGE

GREEN

YELLOW
OCHRE

HOOKER'S
GREEN

PERMANENT
GREEN

BLACK★

VIRIDIAN

WARM SIDE

BURNT
SIENNA

COOL SIDE

PAYNE'S GREY

BURNT
UMBER

PRUSSIAN
BLUE

SEPIA

VERMILION

COBALT BLUE

RED

CERULEAN
BLUE

BLUE

PERMANENT
RED DEEP

ROSE
MADDER

FRENCH
ULTRAMARINE

★
★

QUINACRIDONE
ROSE

★ BLACK MIXED FROM
BURNT UMBER, VIRIDIAN,
FRENCH ULTRAMARINE
AND ROSE MADDER.

★★ PURPLE MIXED FROM
QUINACRIDONE ROSE AND
FRENCH ULTRAMARINE.

PURPLE

■ This colour wheel was created using the colours in my paintbox, showing their relative warmth and coolness: the reds and oranges on the left side are warm, while the blues and greens on the right are cool. Note how each of the colours veers towards warmth or coolness. There are 'warm' orange-reds such as vermilion, and 'cool' blue-reds such as permanent red deep and quinacridone rose. Some yellows incline to orange and are warm, while others are slightly green, inclining towards blue. Although blue is a cool colour, some blues appear warmer than others; for example, french ultramarine has more red in it and is judged to be warmer, while prussian blue is a cooler blue. The colours on the outside of the wheel are the colours on the spectrum; where they are opposite each other they are complementary. The colours inside the wheel are produced by mixing three colours together (tertiaries) and relate to black which is in the centre.

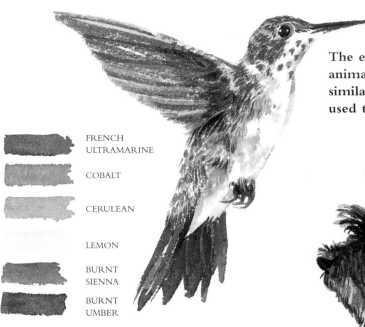

The examples given here of a variety of animals and their palettes give an idea of the similarities and differences between the colours used to paint them.

FRENCH ULTRAMARINE

COBALT

CERULEAN

LEMON

BURNT SIENNA

BURNT UMBER

SEPIA

FRENCH ULTRAMARINE

■ **Above: For this humming bird, mixes of burnt sienna and burnt umber provide the main colour with the lemon and blues used to achieve the iridescence on the feathers. A mixture of french ultramarine and burnt umber creates the shadows, beak, and eye.**

■ **Above: Just two colours are used to create the various shades of grey in this handsome dog. The strength of the sepia and french ultramarine mix is varied by adding or reducing the amount of water used to give light and dark greys.**

■ **Right: An initial wash of yellow ochre mixed with sepia is used to create the high-lights on this horse's coat. Burnt umber provides the mid tone and is mixed with french ultramarine to make the shadows and harness. The same mixture is used for the black on the eye. A touch of a pale vermilion wash gives the faint pink on the nose.**

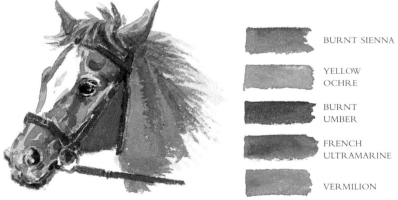

BURNT SIENNA

YELLOW OCHRE

BURNT UMBER

FRENCH ULTRAMARINE

VERMILION

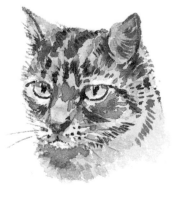

YELLOW OCHRE

SEPIA

FRENCH ULTRAMARINE

AZO YELLOW

PERMANENT GREEN

■ **Left: Yellow ochre, sepia and french ultramarine are the main colours in this cat's head. A wash of yellow ochre mixed with sepia is used to make the pale tabby fur. When this wash is nearly dry, the stripes are added using a mixture of sepia and french ultramarine, which is also used in the shadow areas. Azo yellow mixed with a little permanent green gives a lovely yellow-green for the eyes.**

MAKING YOUR SELECTION

At the beginning of this chapter I drew your attention to the different materials, techniques and approaches that different animal subjects require. The drawings on this page demonstrate two alternative ways of conveying the enormous bulk and the ponderous nature of the elephant with bold strokes of soft pencil or conté crayon. These are contrasted with the delicate drawing of the timid and shy mouse, conveying in fine pencil lines and soft shading the irresolute nature of the creature.

Choose drawing tools, painting materials and paper that suit your subject, and that suit each other. If you are working outside or going on holiday don't take drawing tools or paints which are unfamiliar. It is daunting enough to be working somewhere different without having to struggle with a new medium, and although it might have looked easy to pack or carry, you will be much better off with something you know.

■ **Below: The craggy hide of the elephants was rendered effectively with conté crayon (a hard pastel).**

When packing for a drawing or painting trip, include a selection of drawing materials to suit different subjects: pencils (hard, soft and watersoluble), a stick of charcoal, a soft crayon and a felt-tip pen, for example. Take of pair of binoculars for closer observation.

Always make drawings before you paint because you will need to gather information before embarking on a painting. Use a large sketch pad so that you can record several sketches and use it to record information for later work *not* for making 'works of art' – unless you are drawing for its own sake. Even then, don't set out to make 'beautiful' drawings because these will happen anyway, provided you record what you see as accurately and as well as you can!

■ **Right: The nervous twitchiness of the mouse is reflected in the delicate and subtle line of a 2B pencil on smooth paper.**

■ The large, robust yet
gentle forms of these
young elephants is
sensitively depicted by the
loosely hatched lines of a
soft 2B pencil on
cartridge paper.

Developing confidence

All artists, whatever their subject, need confidence if they are to draw well and with enjoyment. Confidence gives you courage, and you certainly need courage to make a mark on that pristine expanse of white cartridge paper. You need courage even to make a start on a drawing of a shifting herd of cattle, or a fluttering flock of doves or pigeons. So how do you convince yourself that these subjects are within your capabilities?

Building confidence is a step-by-step process. First you must overcome your initial fear and make that first mark. You must be prepared to take risks, and above all you must be prepared to risk failure, because you often learn more from your mistakes than from your successes. And above all you must practise: take every opportunity to make drawings, and have sketchbooks and drawing materials ready to hand at all times – even the slightest, quickest sketch will help to sharpen your powers of observation, and hone your hand to eye co-ordination. And all the time you will be building a library of material which may trigger a big idea or provide valuable reference.

Fortunately, there are ways of approaching drawing and painting animals which make the subject more approachable and encourage you to get on and draw. As I indicated in the Introduction, the most important thing is learning how to 'look', and in this chapter I will suggest ways of looking at animals so that you really 'see' them, and *understand* what you are seeing. These are not tricks or short-cuts, they are simply tried and tested methods which have helped me to focus, analyse and interpret the natural world, so that I can now draw and paint with confidence.

To draw accurately and efficiently you must learn to select the essential elements of a subject and edit out the non-essentials. By simplifying the forms you make the subjects seem less daunting, and you will also be able to record them quickly – very important

■ Study the subject carefully – if you half-close your eyes it will help you to concentrate – and try and see it as a simple shape such as a cube, cylinder, sphere or cone. You will find that this gives you a very useful start for your drawing and the more you do it the easier it will become.

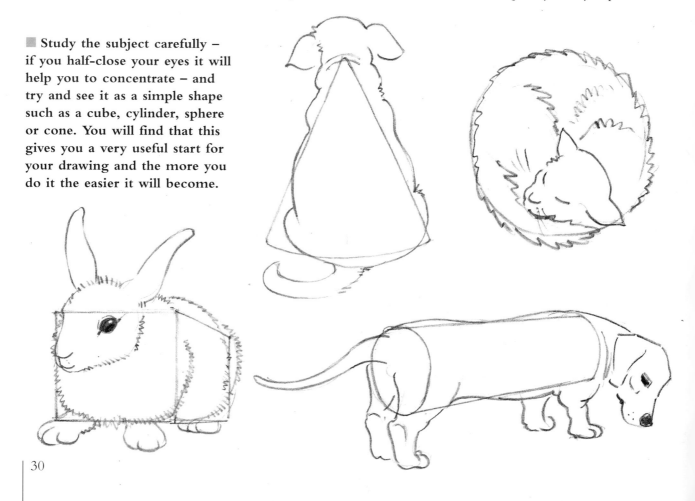

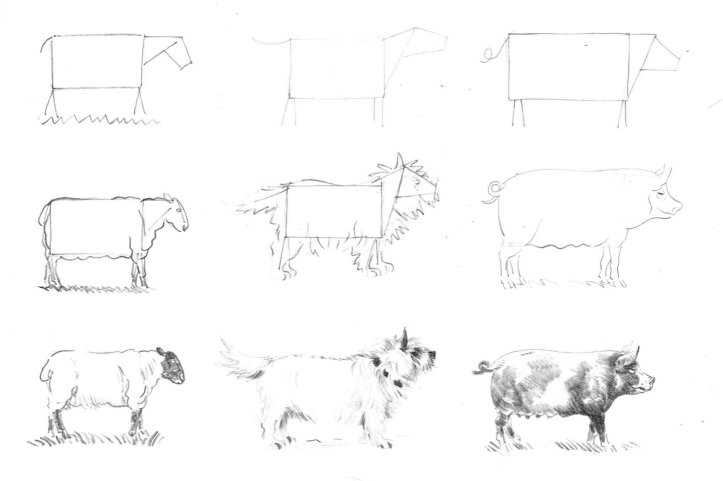

with animal subjects which are often on the move. Success breeds success, and as you begin to produce better drawings your confidence will increase, and you will begin to feel more relaxed and comfortable. There is no substitute for practice, practice, practice – so although I hope you will read what I have to say, it is even more important that you find similar subjects, master the techniques I describe and try the exercises. You will be surprised to find how quickly your work improves. Soon you will find that you are able to capture the essence of a subject and record it concisely and accurately. These skills are wonderfully liberating, and a superb foundation for gathering and recording material, and producing finished images.

SIMPLIFYING THE FORM

The great French artist Paul Cézanne (1839–1908) said that 'all natural forms can be resolved into the cube, the cylinder, the cone and the sphere'. I would add to his list the rectangular box. You will find the 'matchbox' a useful basic building block for most

■ **Animal forms can be broken down into a series of geometric shapes. To construct a sheep, a 'matchbox' shape is required for the body, a cone for the head and neck, and tapering cylinders for the legs. The same basic shapes have been used to construct a side view of a pig and a terrier.**

mammals and by adding other geometric shapes you can construct a solid and convincing form.

Animals rarely stand still to be drawn; more often they are on the move so that you have very little time to make a drawing, and simplifying their form into a series of basic geometric shapes gives you a good starting-point. Rather than wasting time puzzling about what you can see, you impose a simple structure which can then be used as a scaffolding on which to construct the drawing.

The matchbox method of construction also makes the effects of perspective on the form of the animal much easier to understand.

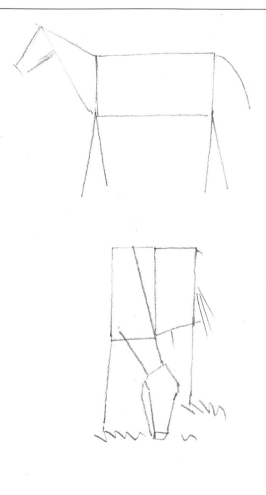

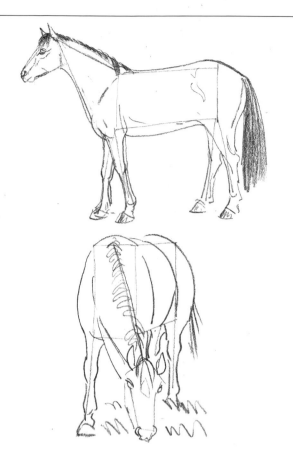

1

2

In these drawings of a horse you can see the effects of perspective on an animal which is turned fully towards you. When viewed side-on (1) the horse has little 'depth' and so there is little recession – but note that the legs furthest away appear shorter to suggest that they *are* further away. In view (2) the horse projects into the picture space, and so the effects of recession are more apparent.

In the drawings of a cow shown here you can see how the matchbox construction makes the perceived form much easier to understand. You can draw the details of the form over the simplified but accurate structure.

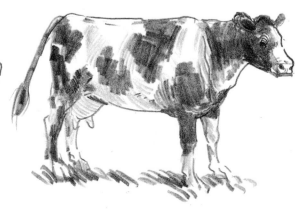

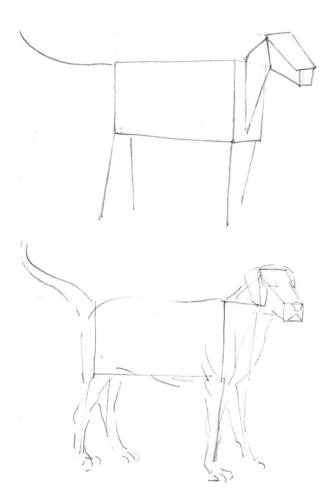

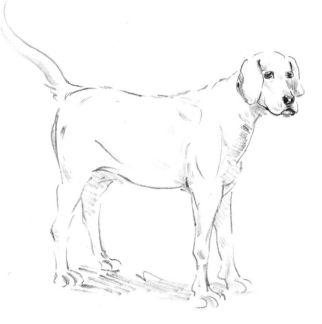

■ **Above: This dog is turned to a slightly three-quarter view; the matchbox body is slightly tapered at the rear and the neck is foreshortened.**

■ **Below: This cat has been drawn in perspective using the same principle as for the dog and horse, but notice that I have used cone shapes on which I built the structure.**

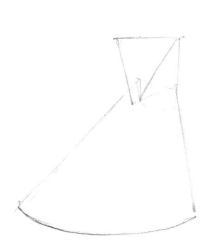

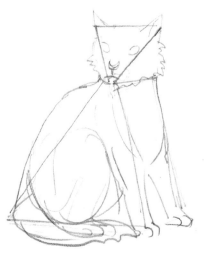

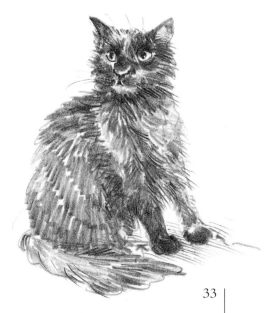

PROPORTION

I used to watch artists standing in front of a subject holding a pencil at arm's length, and wonder what they were up to. Later I discovered that this procedure was actually a very useful method of 'measuring' what you see and establishing the proportions of different elements. It allows you to create accurate drawings.

Stretch your arm out in front of you, close one eye – this flattens the form and makes it easier to concentrate on the shape – and align the top of the pencil against the top of the head of the animal. With your thumb, mark where the end of the nose is: this is your basic measuring unit. Keeping that measurement and your arm outstretched, lay the pencil against the neck and check how many times the head measurement goes into its length. Do the same with the back, the depth of the body at its deepest (behind the front legs), and finally the length of the legs. You can use these measurements of comparison to mark out the proportions of your drawing, and everything will relate.

Unlike buildings, a still life or a landscape, the animal will probably walk off as soon as you start, so try this exercise on photographs first.

ONE
HEAD'S
LENGTH

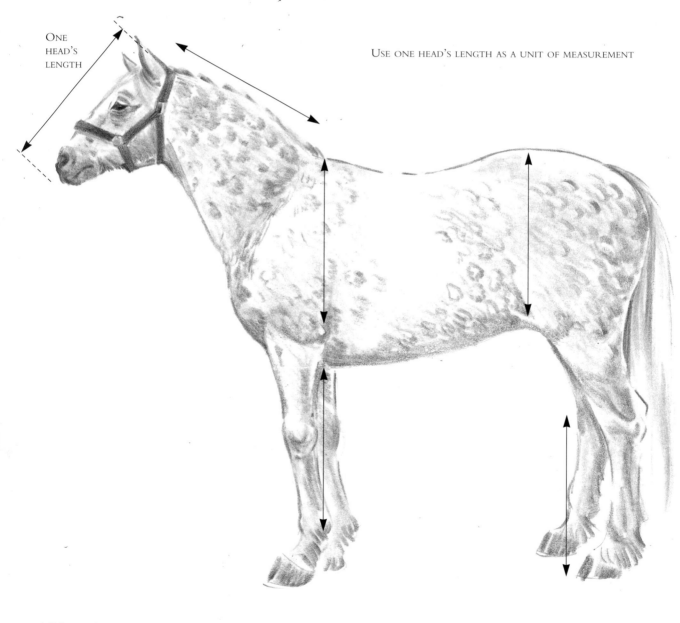

USE ONE HEAD'S LENGTH AS A UNIT OF MEASUREMENT

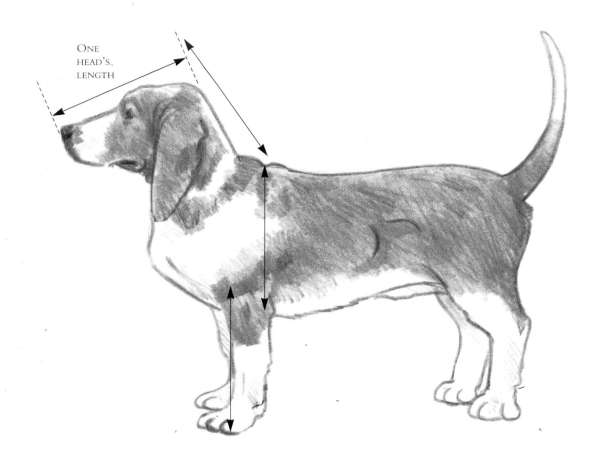

ONE
HEAD'S.
LENGTH

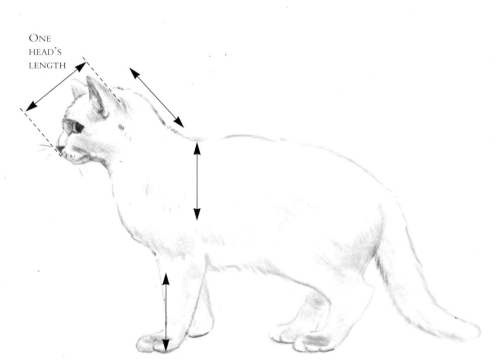

ONE
HEAD'S
LENGTH

■ The proportions of animals vary from species to species and from breed to breed. Here you can see that the length of the horse's head gives you the length of the neck. On the cat and the beagle the proportions are different (the beagle's head, for example, is longer than its neck). Once you have established the basic unit of measurement, you can work out the relative proportions of the rest of the animal.

THE THREE GREAT DIVISIONS

What I refer to as the 'three great divisions' are the three places at which the body is divided. These divisions occur between the neck and shoulders, the shoulders and belly, and in the area where the hindquarters and stomach meet, and are visible as a series of curved lines. These are points at which the animal articulates. Their relationship to each other changes as the animal moves and turns, and they allow you to see and understand the pose. If the animal is standing head-on towards you, the effects of perspective will make the three divisions appear close to one another. In a side-on pose they will appear farther apart. These curves provide a valuable peg on which to hang the rest of the form, so it is important to identify them and indicate them in your drawing.

THREE GREAT DIVISIONS

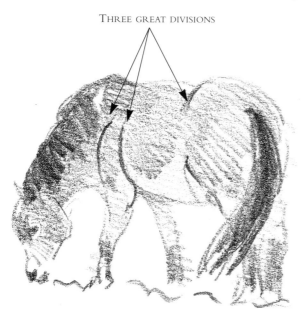

EXERCISE: *Split the three divisions into shapes, like a jigsaw. Practise drawing these shapes until you can reassemble the animal quickly and easily.*

THREE GREAT DIVISIONS

THREE GREAT DIVISIONS

■ The three great divisions can be seen in all mammals, although the relationship between these three key points appears to change as the animal shifts its position. They are easiest to locate when the animal is standing, side-on to the viewer, and they are most helpful when you are trying to 'sort out' the structure of an animal that is lying down or curled up.

THREE GREAT DIVISIONS

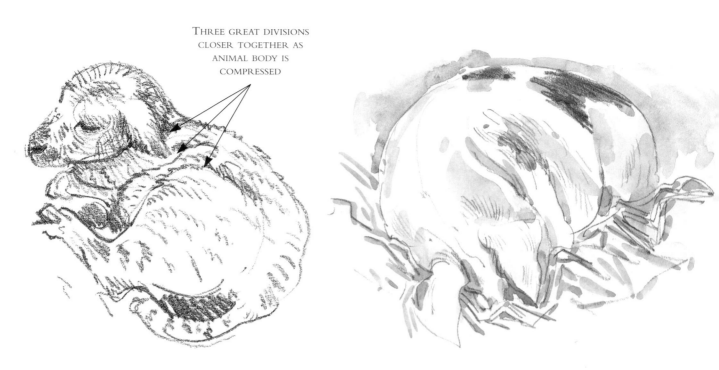

THREE GREAT DIVISIONS
CLOSER TOGETHER AS
ANIMAL BODY IS
COMPRESSED

■ **Above: When the animal is facing forwards or away from you, the spaces between the three great divisions are foreshortened. The divisions are especially helpful when you are constructing** a difficult pose. Start by indicating them on your drawing – usually as three curves – and you will find that the drawing comes together more easily.

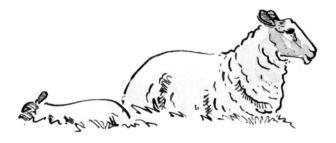

■ These sketches of sheep and lambs in different poses all show the three great divisions.

SILHOUETTES

A useful confidence-building exercise is to practise drawing animals' silhouettes until you become familiar with the proportions and outline. Trace shapes from photographs and accurate pictures – an excellent project for winter when the weather prevents outdoor work.

When I was young and mad about horses, I used to trace their shapes from photographs. One day I found I could draw something tolerably like a horse, freehand. I remembered the shapes I had traced and found this a tremendous help.

Making silhouettes will familiarize you with outline shapes and proportions, giving you a greater understanding of the mass of the animal's body without getting involved in expressing this in terms of tone. By looking at the space outside the silhouette (the space between the body and the ground, for instance) you will also train yourself to see more clearly. Silhouettes can give clues to the animal's character, but generally they have a fairly static appearance, and their main use is as a way of understanding form.

Try to find photographs of an animal in different poses and actions. A composite page of silhouettes from different views will be very useful reference.

■ **Copying or tracing animal silhouettes will help develop your visual memory and will be a great help when you are sketching or trying to capture a lifelike animal portrait.**

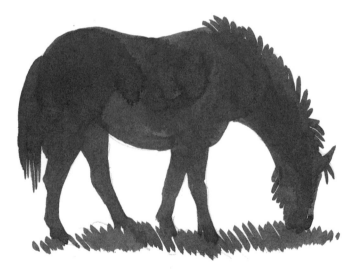

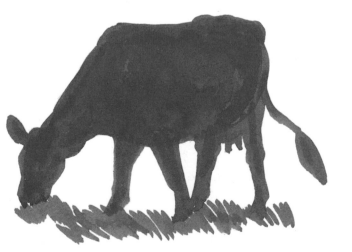

ANATOMY

An understanding of anatomy is useful to the animal artist, and if you are really serious about animal art you will have a book on animal anatomy on your bookshelf. It isn't necessary to be able to name all the bones or to know the detailed muscle and sinew structures, but you do need to understand basic anatomy because it provides the foundation of the animal's form. Even a sketchy knowledge will help you to understand the structures and outward appearance of the animal being observed. The joints affect the way the animal moves, and the bones or muscles that lie close to the surface affect the way that light falls on the animal.

Mammals have very similar bone structures, but it is noticeable that some have longer bones than others. In some breeds of dog, for example, the skull is quite short and blunt, while in other breeds it is elongated. All dogs, however, have eye sockets, they all have nose cavities, and the neck bones occur in the same positions. This is the basic information with which you should be familiar, even if you are a landscape painter – it will prevent your sheep from becoming blobs on the landscape.

■ **The skeleton provides the framework for the animal: the muscle and the fatty tissue over the skeleton soften the form and make it bulkier. For example, the nose consists of a large section of cartilage tissue below the nose bone; and ears, too, are formed from cartilage.**

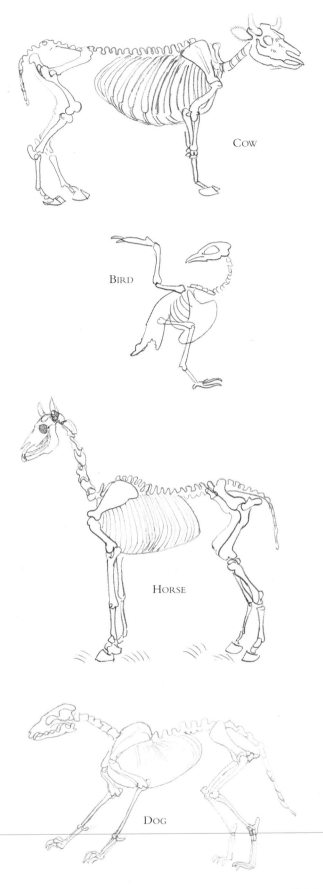

COW

BIRD

HORSE

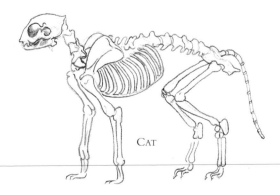

CAT

DOG

The way an animal walks can only be understood by observing the living subject. You need to study the limits of movement of the joints, the precise way they move and the directions in which they can move. You will find that it helps if you match the animal's movements with the joints in your own legs and arms.

The skull requires special study. There is no short-cut to careful observation, but knowing what to look for is helpful. Most animals of a particular species have approximately the same shaped skull, although there are differences, between breeds of sheep, for example. Leicesters have Roman noses while Dorset and Romney Marsh sheep have exceptionally short, broad faces. Horses too have varied profiles, from the heavy heads of draught horses such as Clydesdales to the delicate dished faces of Arabs.

Dogs display most variation in skull and body shapes. Think of a bulky bulldog, a small terrier and an elegant spaniel: they have the same basic skeleton, but the proportions of the bones within it are very different.

You will find it helps to reduce the head to a simple geometric shape. The heads of sheep and horses when seen from the front are coffin-shaped, while cats have hexagonal faces. When drawing or painting an animal, take a look to see where in its body the bone lies close to the surface, as in these places it will cause sharper highlights than in areas where muscle overlies the form. The bones of the skull tend to be close to the surface – the bones of the nose and edge of the cheekbone are especially prominent.

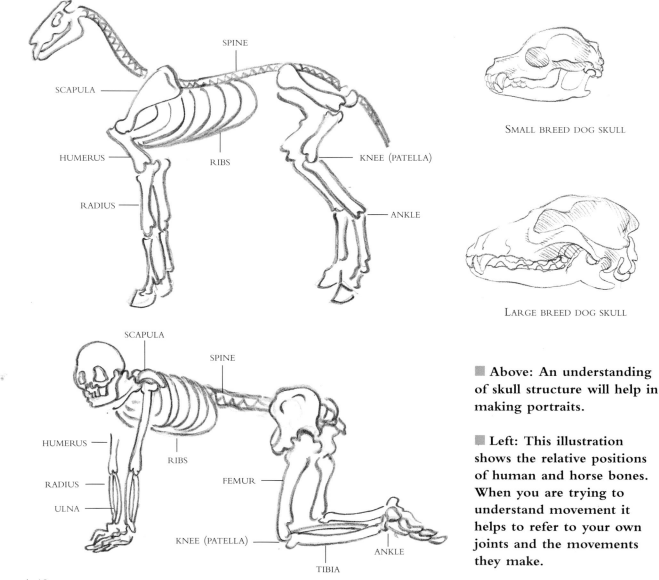

SPINE

SCAPULA

HUMERUS

RIBS

KNEE (PATELLA)

RADIUS

ANKLE

SMALL BREED DOG SKULL

LARGE BREED DOG SKULL

SCAPULA

SPINE

HUMERUS

RIBS

RADIUS

FEMUR

ULNA

KNEE (PATELLA)

ANKLE

TIBIA

■ **Above: An understanding of skull structure will help in making portraits.**

■ **Left: This illustration shows the relative positions of human and horse bones. When you are trying to understand movement it helps to refer to your own joints and the movements they make.**

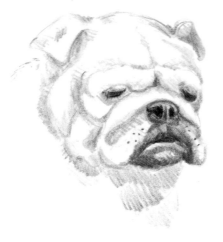

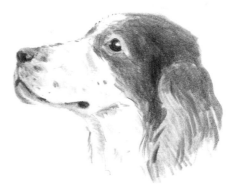

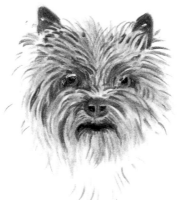

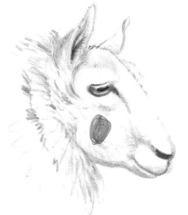

■ Although the same bones are present in the skulls of animals of the same species, skulls can vary in shape and size as shown by these illustrations of different breeds of dogs, sheep and horses.

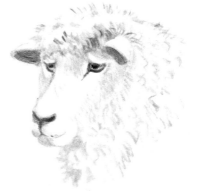

EYES

The eye consists of a large, soft globe set 'into' a bony socket and surrounded by fatty tissue – it isn't an oval set 'onto' the animal's head. If you are aware of the three-dimensional character of the eye you will find it easier to depict it accurately. While all eyes are much the same in structure, they do occupy different locations in different species. In horses, cows and sheep, for example, the eyes are set on the sides of their heads. In cats, dogs and bears, on the other hand, the eyes are set on the front of the head.

There are a few key points to look for when drawing eyes: the angle of the eye, the place where the highlight occurs, and the shadow cast by the top lid. Notice that the highlights on the eye are often round because the surface of the eye is curved. The pupils vary according to the species: in sheep and goats they lie laterally, while cats and members of the cat family have pupils that widen and contract depending on the light and whether the animal is excited. If you observe a cat chasing a toy you will see that its pupils are dilated, but if it is sitting in the sun they will have contracted to slits. In horses and cattle the iris (the coloured part) and pupil are both so dark that they appear to be one feature. You can see very little of the white of the eye unless the animal is excited or frightened – then they roll their eyes revealing a lot of white. Dogs also show very little eye white, while in rodents the eye is completely dark and full.

TIP: *Make the animal's eyes the darkest tone available and place the highlight correctly to make the subject look convincingly alive. Observe the eye carefully and draw or paint exactly what you see, remembering that the eye is a globe so its surface is curved and therefore the highlight will be too.*

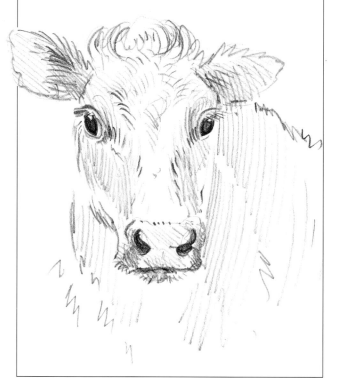

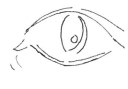

1

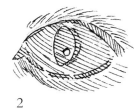

2

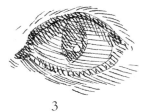

3

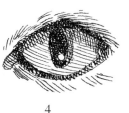

4

■ **A fine technical pen was used to produce this detail of a cat's eye. Start by establishing the basic outline – indicate the vertical slit of the pupil and the small, bright area of highlight (1). Now use fine lines to describe the fur around the eye, making sure that your marks follow the direction of growth. Use regular hatching to create a mid-tone on the eye (2). Use a darker, cross-hatched tone for the shaded areas where the eye recedes into the eye socket, and for the shadow cast by the upper lid (3). Complete the drawing by adding the areas of darkest tone. Build up the hatching in the pupil – the darkest part of the drawing – being careful to retain the highlight. Add more dark tone just inside the upper and lower lids.**

■ The step-by-step construction of the eyes of a horse, cat, sheep and rabbit is shown here. Although the eyes differ in shape, detail and colour, the process is the same as that used for the cat's eye described opposite. Start by drawing the basic shape. Note that the upper lid extends beyond the lower lid, and that the lids don't actually join at the corners. The top lid overhangs the eye, like the eaves of a house, casting a shadow over the iris in animals with light-coloured eyes. This shadow sets the eye into the socket and prevents the 'staring eyes' look. If you are working in watercolour, start with light tones and build up to dark tones, taking care to retain the white of the paper for the highlight. Look for the areas of tone, for it is the gradations of tone from light to dark which give the eye form.

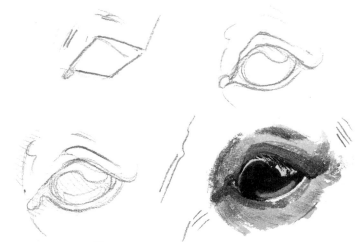

HORSE

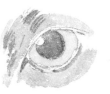

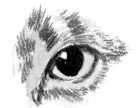

CAT

SHEEP

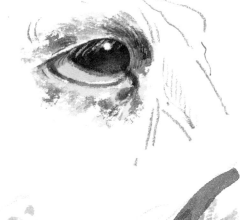

RABBIT

NOSES AND MOUTHS

Noses vary tremendously from one animal to another. In the horse, the nose is soft and curling, but the nostrils can flare and open wide if the animal is excited or working hard. Sheep and goats have a little narrow slit on each side of the nose; these meet together in the centre and join the top of the lips, almost like a hare lip. This type of nose is also found in rodents, mice, rabbits and squirrels and there is a slight indentation in the noses of dogs too. Study the way the shape of the nose starts to form part of the mouth. A cat has a snub nose, which gives it a short face.

■ **The nose and mouth are important aspects of an animal's character. By understanding the underlying structures and the animal's method of feeding, and by looking very carefully, you will be able to produce accurate and images full of character. As with the eye, start by establishing the broad outlines, reducing the forms to their bare essentials. Then apply the colour and tone, paying special attention to the areas of light and dark which will suggest the volumes and shapes. Half-closing your eyes will help you to focus on the essentials and edit out the non-essentials.**

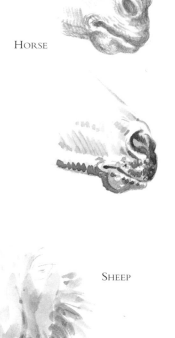

HORSE

SHEEP

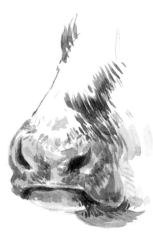

COW

CAT

DOG

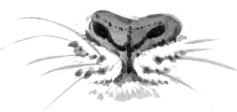

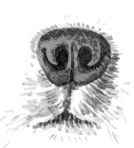

The shape of an animal's mouth depends on the type of teeth it has, and its method of feeding. Cats and dogs are carnivores and have highly developed eye teeth for tearing meat, and the appearance of the mouth is affected by these big teeth. Members of the cat and dog families also have wide mouths which can open as far back as the eyes, so that they can hold prey. Herbivores such as horses, cattle, sheep and deer have long jaws extending beyond the eyes, but their mouths were designed for chewing and so do not open as wide as those of cats and dogs. Omnivores such as pigs have wide-opening jaws, with a curved mouth to accommodate the eye teeth.

Noses and mouths are formed from cartilage and muscle respectively which are softer than bone, and produce a less sharply defined outline. The nose and mouth are often interconnected by a line, as in cats, dogs and sheep. Look carefully at the shape of the centre line between the lips: in most cases, unless there is a malformation caused by breeding, the top lip overhangs the lower one, creating a shadow on the lower lip. The area around the nose and mouth is often one of the darkest parts of the body, but do not exaggerate the tone too much.

■ **Notice the way the pig's mouth curves over the eye teeth so that it appears to be smiling.**

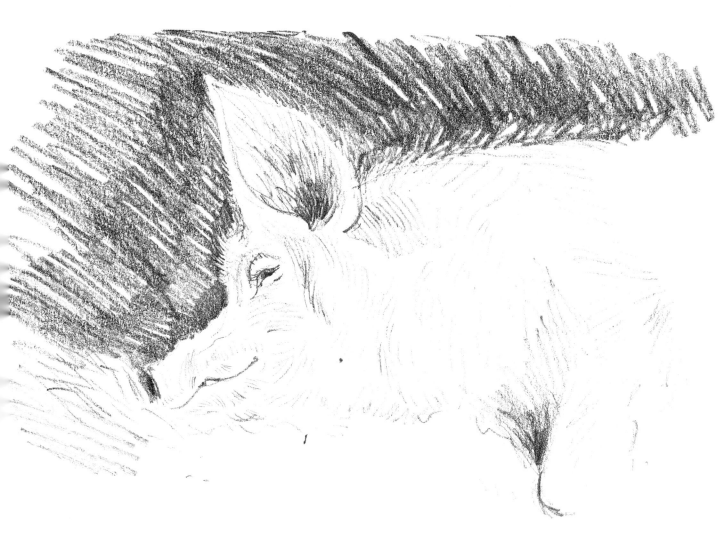

EARS

Ears are a very expressive part of an animal's anatomy and can tell you whether an animal is alert, startled or relaxed. They are so varied in shape and size that they appear to have little in common; however, in spite of superficial differences they are all basically constructed of delicate pieces of cartilage covered with hair or fur, and are controlled by muscles. They are more mobile and softer than bony structures, and you should try to convey this quality in your drawing. In mammals the ears lie above and behind the eye, and a little below the top of the head – not on top of it.

■ **Study your animal's ears carefully – do they flop, come forward, or prick up? Careful observation and accurate drawing of the ears will give the animal character. Because ears are so diverse you will find it helpful to reduce them to a geometric shape, and use that as a basis for the drawing. Many are diamond- or leaf-shaped, and most of them have folds, so look for the shadows within the folds.**

SHEEP

ZEBRA

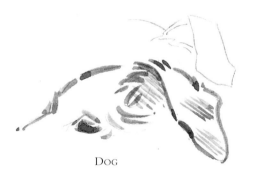

DOG

CAT

HORSE

COW

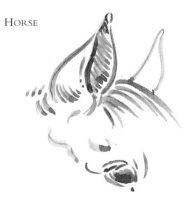

FEET

Feet are often difficult to see and because of this, there is a temptation to pay less attention to them than to the rest of the animal. However, they are an important part of its form, and dictate the way in which it stands and moves. I have always hated drawing feet but have come to realize how vital it is to get them right.

Mammals divide into those such as bears and badgers which walk on the flat of their feet (plantigrade), cats which walk on their toes (digitigrade), and horses, deer and cows which walk on the extreme tips of one or two of their toes (unguligrade). A walking cat, for example, has the heels of its hind legs in the air but it sits on the whole of the foot of the rear legs.

The angle at which the feet are joined to the rest of the leg should be observed carefully. Feet are mostly offset at an angle, which allows the joints to be cushioned against the downward thrust of the leg and the weight of the body.

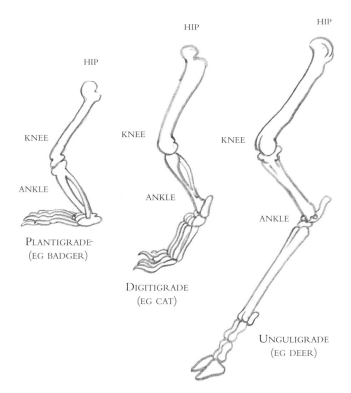

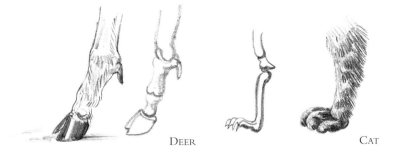

DEER CAT

■ **Above and below: These illustrations show the feet of several animals, together with their underlying bone structure. Note that different animals walk on different parts of the foot. Note also the angle of the foot to the leg.**

■ **Above: A comparison between the skeleton of the hind legs of different animals shows that some walk on the whole foot, some on parts of the foot, while others walk only on their toes. Note the angle at which the foot, or parts of it, lies in order to cushion the weight. This affects the gait and stance of the animal and is worth observing carefully.**

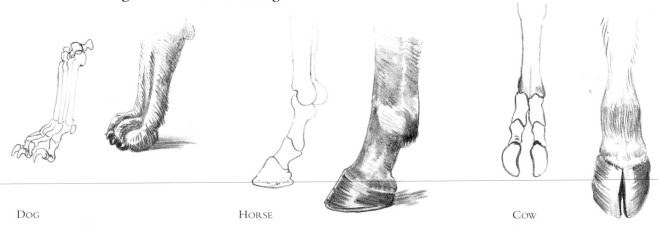

DOG HORSE COW

YOUNG ANIMALS

Young animals have the same skeletal structure as their parents, but the proportions of their limbs and their features are different, and the whole form is softer and more rounded. In newborn animals the skin tends to be loose and sometimes lies in folds, although this disappears after a short time. Newborn animals also have difficulty finding the balance needed for walking and standing, and generally have a staggering gait. Often they find it easier to run.

In foals and calves the legs are disproportionately long so that they can run fast (flight being their only 'defence' against predators) and this gives them their characteristically gangly appearance.

In all young animals (humans included) the eyes are further down the face towards the nose. (If you want to flatter a human sitter, make him/her look younger by lowering the eyes a little!)

■ **In this drawing of a young foal, the rounded forms of the body, the large, rounded leg joints, and the low position of the eyes is established first with a loose pencil line. Hatched tone then fleshes out the form, and adds emphasis to the straddled legs.**

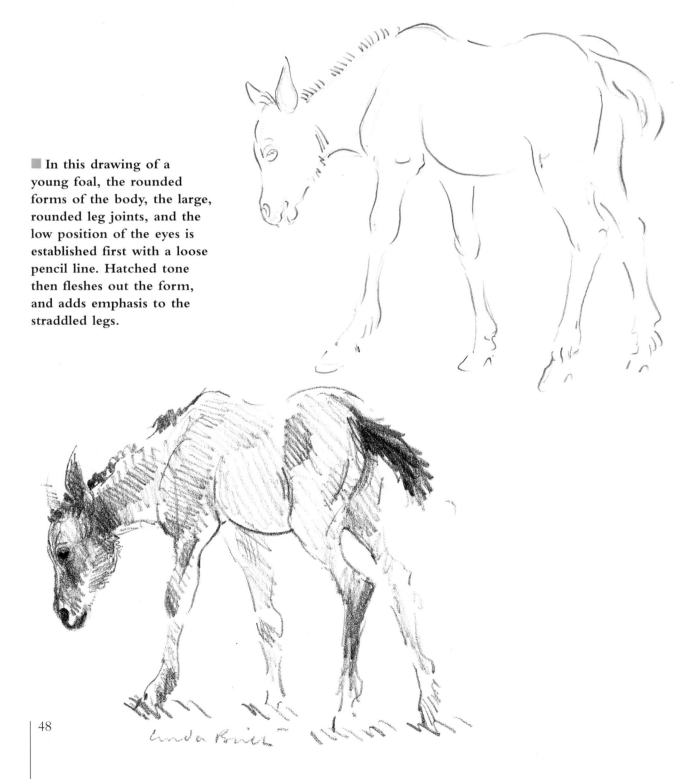

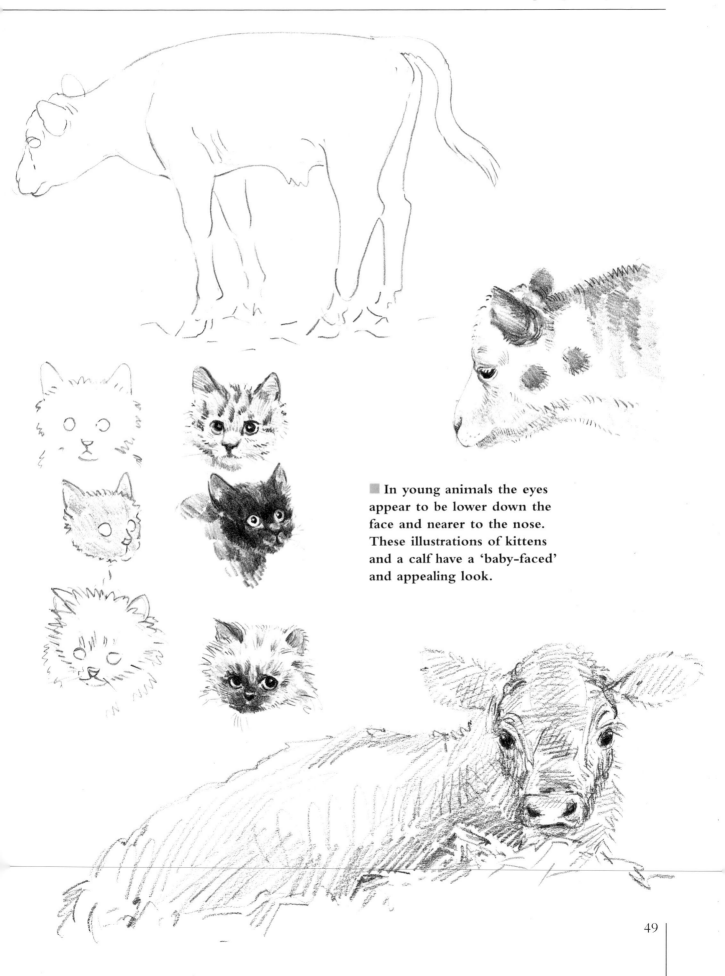

In young animals the eyes appear to be lower down the face and nearer to the nose. These illustrations of kittens and a calf have a 'baby-faced' and appealing look.

BIRDS

We all know that birds are hatched from eggs, but did you realize just how useful the egg shape is? Anyone who can draw an egg can draw a bird, for believe it or not, nearly all birds are egg-shaped! However, both the angle and the shape of the 'egg' vary from one species to another, so robins are round while herons have elongated bodies.

You might think colour and feathers are the most important features of a bird, but an understanding of the skeletal structure is more important – so have a close look at the next chicken you cook! There are a great many curves in a bird's form, so make a point of looking for *straight* lines and emphasize those. In fact, this applies to all drawing, because unless a drawing is being done in a particularly expressive way, there needs to be a balance between straight and curved lines: straight lines give strength and emphasis, while curved ones are graceful and lyrical. Both also have

negative qualities: thus straight lines can look too strong and become aggressive and inflexible, while curves can look limp and weak.

Birds have tiny round eyes, and in small species they are very black and bright. In some birds, such as owls, you can see the iris (the coloured part). Sometimes the eyes are overhung by longer feathers, and in certain birds of prey this accounts for the fierceness of their expression.

Beaks vary according to the jobs they have to perform. Thus birds of prey have powerful curved beaks to tear their prey in order to feed, whereas a wader of estuaries and streams has a long slender beak to probe soft mud to find food. Seed-feeding birds have short blunt beaks for dealing with hard nut- and seed-cases, and ducks have a flat beak which contains rows of sieving plates used to strain particles of food from the water.

Birds do *not* have external ears, even though long-

■ Below and opposite: Using an egg shape as a basis for your drawing will enable you to capture the stance of the bird quickly. This is important when drawing from life because you need to get as much information down as possible before your subject flies away. Add simple shapes for the head and tail feathers. Note that garden birds tend to be tilted at an angle of about 45° unless they are feeding.

■ **Above and right:** Next time you see a duck swimming, notice that it can be seen as an egg lying horizontally, with a smaller egg on top for a head and a cone on the rear end for a tail.

and short-eared owls look as though they do. In fact they have a hole in each side of their heads.

Birds' feet also vary depending on the job they have to perform, although they have the same number of digits. Thus the second toe has two bones, the third toe in the middle has three, while the fourth toe on the outside has four joints. The first toe corresponds to the human thumb and is at the back of the foot: in eagles and hawks it is highly developed so that the bird can grasp prey; on birds which perch it is designed to grip tree branches. In waterbirds the three toes are joined by a web, and the back 'thumb' is scarcely seen, while in the swallow, which remains most of the time in the air, the toes are used for clinging and are clustered together. Woodpeckers and cuckoos have their toes in pairs, two in front and two behind. In all birds the foot is covered in scales which are quite different from the feathers that cover the rest of the body, and which betray birds' common ancestry with reptiles.

■ **Treat birds' eyes in just the same way as the eyes of other animals. Start with a simple drawing of the main shapes, noting exactly where the highlight occurs. Then lay in the light, mid- and dark tones and the areas of local colour. It helps to understand what you are looking at, so for example, if the eyes are light in colour like those of the owl and the buzzard, the feathers above the eye will cast a shadow.**

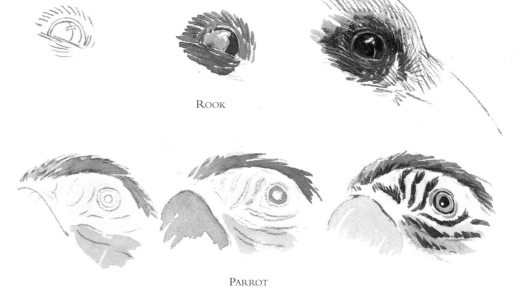

ROOK

PARROT

BUZZARD

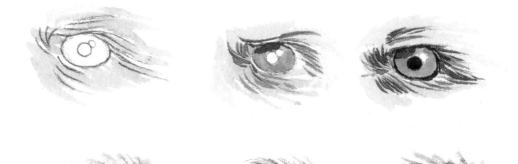

OWL

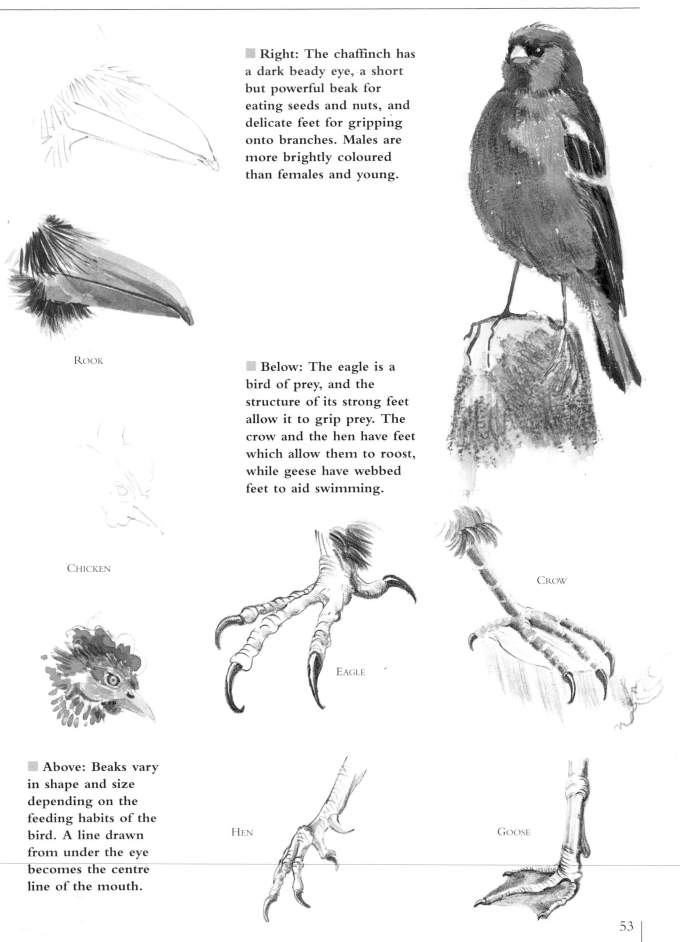

ROOK

Right: The chaffinch has a dark beady eye, a short but powerful beak for eating seeds and nuts, and delicate feet for gripping onto branches. Males are more brightly coloured than females and young.

Below: The eagle is a bird of prey, and the structure of its strong feet allow it to grip prey. The crow and the hen have feet which allow them to roost, while geese have webbed feet to aid swimming.

CHICKEN

EAGLE

CROW

Above: Beaks vary in shape and size depending on the feeding habits of the bird. A line drawn from under the eye becomes the centre line of the mouth.

HEN

GOOSE

CHAPTER 3

Rendering texture

The texture of an animal's fur, hair, wool, scales or feathers is often its most attractive and characteristic feature, and yet for the artist it presents a daunting challenge. These textures of the animal world are incredibly diverse: varied in colour, sometimes distinctively patterned, and reflecting light in different ways. Another problem is the way that fur and hair often obscure an animal's form, so that it is sometimes difficult to understand what is going on beneath the surface.

So what is the best way to approach this challenging aspect of animal art? In this section I will show you, step-by-step, how to create the textures you want, using watercolour and other media combined with watercolour. Rendering texture is not

difficult if you study your subject carefully, and acquaint yourself with a few basic principles before you start drawing.

GROWTH PATTERNS

First, study the way that hair, fur, wool or scales grow. You will find, for example, that the direction of short hair inclines towards the rear end of the animal. A sheep's wool, on the other hand, stands up in ridges at right-angles to its body, and when it moves the ridges become obvious around the joints. They are defined by a change in tone, the areas between the ridges being dark, while the highest points will be lighter. Sometimes there is also a change in the local colour, the surface wool being dirtier than the wool underneath.

■ **These pencil drawings show a range of animal textures.**

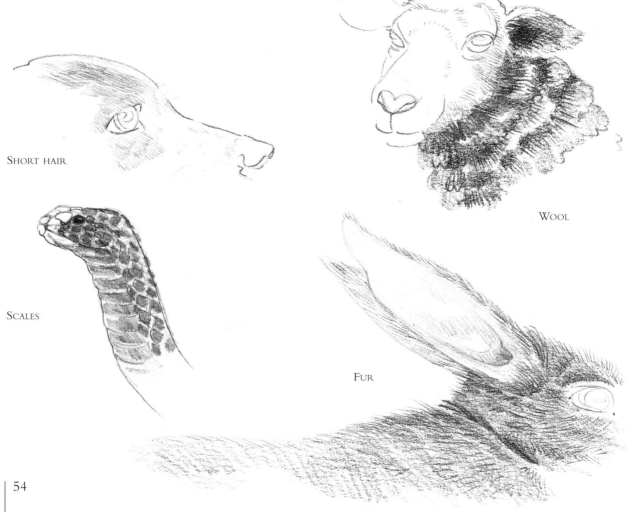

SHORT HAIR

WOOL

SCALES

FUR

Fur consists of two different types of hair: on the surface there are coarse guard hairs, while underneath the hair is softer and more down-like, this combination giving the animal maximum protection against cold and wet conditions.

Scales are arranged in a receding pattern back down the body. Sometimes there are ridged scales on the underside of the belly, on snakes and crocodiles, for example, which help the creature to move.

Hair is fascinating, and the best way to get to know it is by borrowing a friendly cat or dog and examining its coat closely. Start at the nose, and notice the way the fur radiates back over the whole of the face and ears, continuing under the chin and moving down to the chest where it meets in a 'crown'. From this crown it radiates down the back and over the belly and legs. There are other crowns to be found on the body; these mark a change in direction of the body's hair and are a tremendous help in understanding and rendering an animal's coat. Another important area is where the leg joins the body: if your brush or pencil strokes move in the same direction as the hair of the animal, you will find that the result is very convincing.

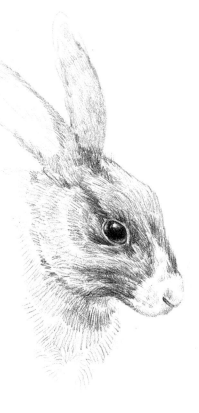

■ **This drawing shows the direction of hair growth on a rabbit's head. Notice the way the hair grows back from the nose and try to follow this movement in your drawing.**

■ **Above and right: The effect of light on an animal form depends on its direction, its intensity, and the shape of the form on which it falls. On the goat, which is bony, it creates a pattern of sharply contrasted lights and darks. Compare this with the softer, more amorphous shadow on the heavily muscled and rounded flanks of the horse.**

LIGHT AND SHADOW

Light and dark (shadow) allow us to see form and three dimensions. Light and shadow also allow us to see texture, and to describe it in pencil or paint. This is why it is so important to draw or paint your subject in a good light, because this allows you to see the contrasts of light and dark, and so to create an image which has solidity. An animal painted in a poor light could look flat and lifeless.

Note in particular the way that the light falls across the nose area, the shoulders and the rump. The highlight will be sharp where bones are near the surface – along the backbone of a goat, for example. On the hindquarters of a horse the highlight will be softer and more diffuse because there are substantial muscles and tissue overlying the skeleton here, and these are less sharp than bone.

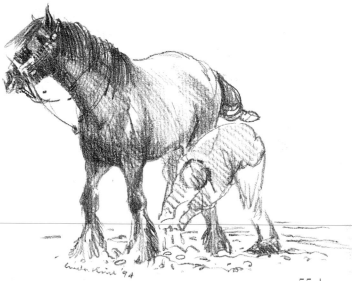

SHORT HAIR

When dealing with short hair or fur the first thing to look for is the direction of light and the way it falls across the form. On smooth, short hair, the transition from light to dark is more even than on long hair. Look for dark accents which can be crisply indicated to give life to the subject. The pattern of light and shadow on the animal is affected by its anatomy. Although you don't have to be an anatomist to paint animals, it does help to have a rudimentary knowledge of what is going on under-neath the surface. Is the animal angular or soft, or a combination of both? If it looks angular that means there are bones just under the skin – these produce sharp highlights. If the animal looks rounded and soft in form, it suggests that the bony skeleton is enveloped in fatty tissue or muscle. It is important to observe these things carefully before you begin to draw.

SHORT HAIR IN PENCIL
The pencil is capable of great sensitivity in rendering texture, particularly short, smooth hair. You can use pencils for rapid, on-the-spot drawings from direct observation, but they are also excellent for more finished drawings. You will need some smooth cartridge paper or Bristol board. You will also need four pencils: a hard 2H for outline and fine lines; a 2B for 'painting' light tones; and a couple of soft pencils – a 6B and an 8B, for example.

Sharpen the pencils with a knife, except for the 2H which can be sharpened with a sharpener as it requires a point. Grind the other leads using a sanding block (or an emery board if there is no sandpaper to hand) to achieve a chisel-shaped tip. This gives you a set of 'tonal' tools – try and think of working in pencil as 'painting' in tone. Use the 2B to lay in the light 'washes' – a smooth paper allows the pencil to glide easily over the surface. The softer pencils should be used to lay in the darkest tones.

The step-by-step pencil drawing of a cow (below) shows pencil used in a carefully considered tech-nique, suitable for creating a finished drawing rather than for a rapid sketch made on the spot. Here, pencil is used as a tonal medium rather than as a linear tool.

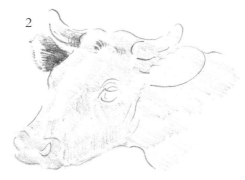

1 Use a 2H pencil to establish lightly the outline of the cow. Do not press too heavily at this stage, as the pencil will make grooves in the paper which will remain even if the marks are removed with an eraser.

2 Work from light to dark (as you would with watercolour). With a 2B pencil lay short, even strokes of tone, following the direction of the hair. This corresponds to the first watercolour wash and establishes the light part of the hair.

3 Use 6B and 8B pencils to build up the darker tones. To keep the drawing fresh, use separate strokes that don't smudge into each other.

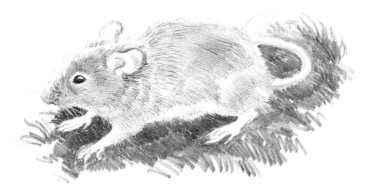

I was able to convey the texture of the fine hair of the mouse by using a combination of two different grades of pencil, taking advantage of the impression left in the paper by using a hard pencil quite firmly.

HIDES IN CHARCOAL

Some animals with little or no hair develop leathery hides for protection. For these animals, such as elephants and rhinoceroses, charcoal is an ideal medium to use.

Charcoal is capable of a range of expressive textural marks. A large thick stick turned on its side can give fine lines and broad areas of texture, which will express the velvety texture of many animals.

■ **Above: The outline of the mouse was made with an H-grade pencil. The same pencil was used to apply short lines over the body, pressing quite hard and following the pattern of the hair. A 5B pencil was then rubbed over the body, letting the impression of the hair show through.**

■ **Right: Charcoal is at its best used on a larger scale, and is ideal for surfaces such as an elephant's hide. Break off a small piece and use it on its side.**

SHORT HAIR IN COLOURED PENCIL

Short hair can also be rendered successfully in coloured pencil. Watercolour pencils can be used wet or dry, or in a combination of both. If you don't use much water, you can use them on lighter weights of watercolour paper or a heavy cartridge paper without stretching the paper first.

Coloured pencils or watercolour pencils used dry have many advantages. They are capable of great subtlety and can be used to depict fine detail. They are easily controlled and can also be erased, which gives the user confidence – they are a great favourite with older children. Coloured pencils constitute a very restful and soothing medium because it takes time to build up the image.

Keep your coloured pencils well sharpened, either with a knife and then sandpapered to a chisel-shaped end (for broad tonal strokes), or with a pencil sharpener to give a sharp point. Coloured pencils and watercolour pencils can be used dry to give texture to watercolour washes.

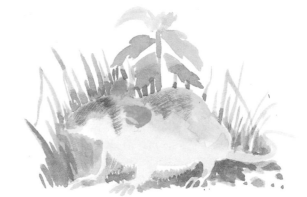

■ **Above, left and below: The mouse was washed with a light mix of ochre and a touch of vermilion. When dry, the fur was dry-brushed with an ochre and burnt sienna mix, and then high-lighted with a sharp brown coloured pencil.**

■ **Above: Watercolour pencils were used wet and dry for this drawing of a pig. Pencil was applied dry, and then washed over with a wet brush to release the colour. Dry pencil was added on top to create the texture of the animal's bristle-covered skin.**

■ **Opposite:**

1 **For this magnificent horse, select a smooth drawing paper to suit the smooth coat of the animal, and five coloured pencils – three different greys, raw sienna and yellow ochre. Start with a simple outline and then hatch in the mid-tones using regular strokes. The white of the paper stands for the highlights, and touches of warm ochre suggest the bulk of the animal.**

2 **Using a range of hatches and stippled marks, develop the image, taking care not to overwork the drawing and allowing the lightness of the marks and the paper to give an impression of the silky sleekness of the horse. Notice that the darkest tones occur on the hooves, under the body, on the muzzle and in the eye.**

1

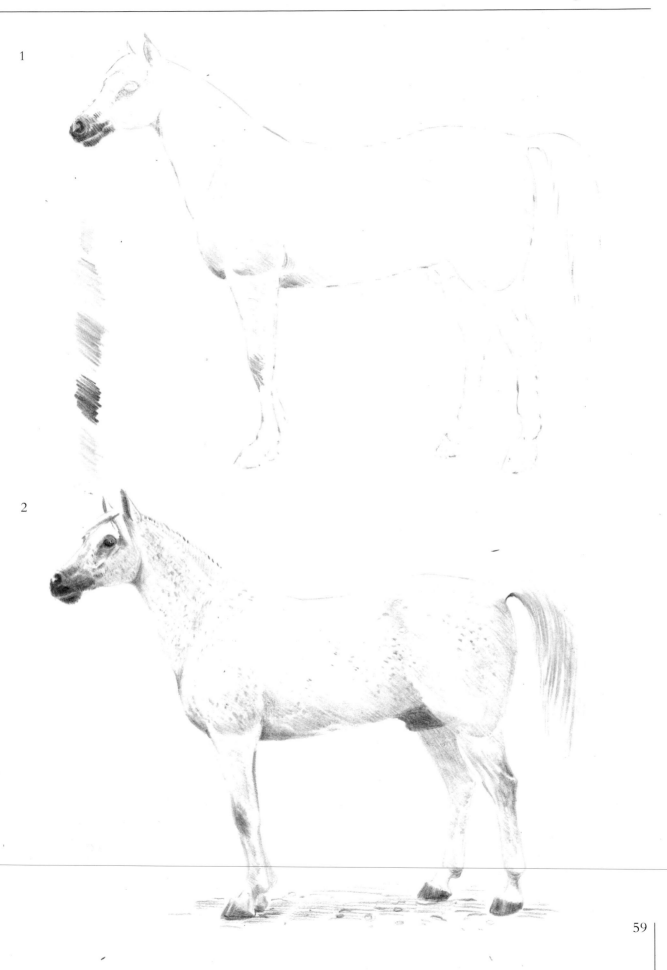

2

SHORT HAIR IN WATERCOLOUR

Watercolour is an ideal medium for rendering animals with short, smooth hair or fur, whether the animal is viewed close up or from afar. A wet-on-wet technique will usually give you the gentle gradations of tone required to convey a softness of form. Start by selecting the colours you will need, though you should limit yourself to four or five – you can extend the range by mixing these in various combinations. Work from light to dark, putting in the lightest tones first followed by darker ones.

Mix your lightest tone first, preparing a larger amount of the wash than you think necessary. If you run out of paint you will have to stop and mix another batch, and it may be difficult to get exactly the same colour. Also, you may find that the painting dries while you are mixing the wash, creating a hard edge where you don't want it. Then mix a stronger wash (more paint, less water) for the middle tone – this may be a slightly different colour.

Using the largest brush with which you feel comfortable, lay the light tone over the entire form, except for the highlighted areas. While the paint is still damp (not wet) drop the middle tone onto the image. Keep well away from the areas you want left as the lightest tone (you could indicate this in your pencil drawing), because the second colour will 'creep' into the first colour, creating a soft diffusion of tone from light to dark. Don't worry if your first attempts aren't successful – you need to practise to get the feel of the paint, the way it responds to the paper, the way it dries and the way one wash reacts to another. This wet-on-wet technique requires practice and confidence – even a certain recklessness. It should look effortless, even though we know it isn't. Wet-on-wet watercolour has a freshness and apparent ease which is effective and appealing, so it is well worth mastering the technique.

Shadows should be darker versions of the colours on the animal's coat. Try adding some blue to the mix – blue is recessive, and will help your shadow plane recede as it should.

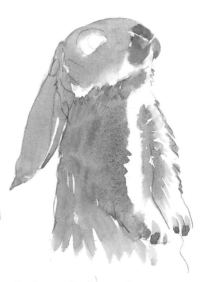

1 First establish the broad outlines of the animal's form, working lightly and loosely with a 2B pencil on smooth paper that has been stretched on a board.

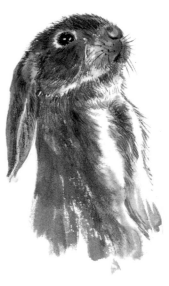

2 Lay a light wash (using french ultramarine and burnt sienna), avoiding any areas to be kept white. Use burnt sienna for the nose. Then wet the white areas with clean water, letting the wash flow into it, to give a furry appearance.

3 Once the first wash is dry, apply a darker mix of the same colours on top of it, leaving the lighter wash to show through in some places. Short brush strokes will add texture to the painting.

4 Finally, add the eye (a deep mix of french ultramarine and burnt sienna) and other details. Give the fur a slightly rougher texture by using a nearly dry stiffer brush with deep grey.

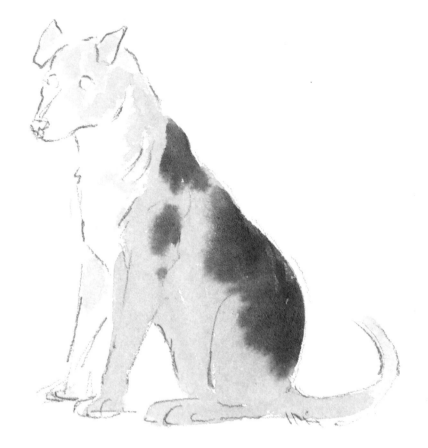

■ If you quake at the thought of using watercolour wet-on-wet, try this painless method of achieving the same effect: lay in your lightest tone and allow it to dry. Using a clean brush and water, dampen (do not wet) the areas in which you wish to lay your middle tone, ensuring you go slightly beyond the area. Drop your tone into the middle of the damp area and it will spread gently outwards, creating an effect which is very like that achieved using the wet-on-wet technique.

TIP: *The fewer colours you use, the better: if you use too many you will find it difficult to keep track of your mixes, resulting in muddy colours. A 'limited' palette of a few carefully selected colours will give you more control, the colours will remain fresh, and the image will hang together because the colours will be related.*

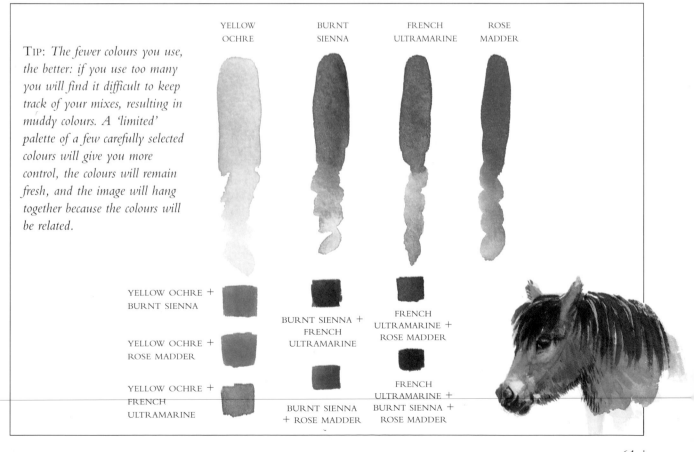

YELLOW OCHRE

BURNT SIENNA

FRENCH ULTRAMARINE

ROSE MADDER

YELLOW OCHRE + BURNT SIENNA

YELLOW OCHRE + ROSE MADDER

YELLOW OCHRE + FRENCH ULTRAMARINE

BURNT SIENNA + FRENCH ULTRAMARINE

BURNT SIENNA + ROSE MADDER

FRENCH ULTRAMARINE + ROSE MADDER

FRENCH ULTRAMARINE + BURNT SIENNA + ROSE MADDER

1 Start with a simple outline drawing in 2B pencil of the dog's head.

1

3

2 Use a mix of light permanent red and gamboge, and wash this over the coloured parts of the dog. Add shadows to the white parts of the face using cobalt blue and quinacridone rose.

2

3 Add burnt umber to the mix to make a darker colour for the ears, top of the head and chin. Mix black for the eyes from quinacridone rose, ultramarine blue and burnt umber. Add slight texture to the coat with a dry brush and the darker brown mix.

1 Working directly with watercolour (without a preliminary pencil drawing) establish the broad outlines with a pale wash of cobalt blue and use the same mix for the shadows. Allow the first wash to dry, and lay a wash of cadmium yellow and vermilion on all coloured parts – this provides the highlight for the coat.

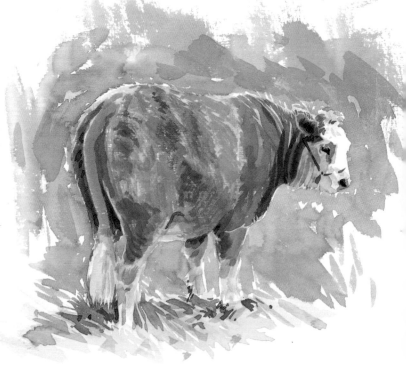

2 Build up the body with denser mixes of yellow ochre, burnt sienna and Payne's grey.

LONG HAIR

Long hair or fur behaves in the same way as short hair in that the hairs grow in the same direction, but the form and pattern of growth may be obscured. The thickness of the fur can create misleading shadows in places. If the animal's coat is particularly rough, you must be aware of the bones and muscles under the surface. If the animal is parti-coloured you will have to face the challenge of tone caused by both light and the local colour in the same subject. To see these effects more easily, make sure that the animal is well lit. Half-close your eyes to identify the main areas of light and dark – this helps to eliminate unnecessary detail and create an understanding for modelling form.

Imagine the animal turned to some hard material such as stone, and think where shadow might be cast by the tufts or massing of fur or hair. Always draw the form of the animal first, then add the hair or fur: it is important always to remember the form underlying the hair and fur, which are merely superficial.

LONG HAIR IN PENCIL

The basic approach to drawing animals with long hair or rough coats is similar to that for drawing short-haired animals, but there are some aspects that must be given special consideration.

Start your drawing by establishing the basic form of the animal, simplifying the form into geometric shapes if you find that helpful. Begin to work the tone by laying in a 'wash' of mid-tones with a 2B pencil, following the direction of the growth of the hair and using long strokes to imitate the appearance of the hair, whether it is springy, silky or coarse, for instance. Then begin to darken the tones, using softer grades of pencil (such as a 6B and an 8B), to give depth and interest to the texture. Finally you should describe the darkest, shaded areas – under the arms, the chin, within the nostrils, the mouth and, of course, the eye.

TIP: *Keep your pencils as sharp as possible when working with softer grades to keep the drawing lively with a really 'hairy' quality. To prevent your hand from accidentally smudging the drawing and losing its freshness, rest your hand on a clean piece of paper while you are working.*

1 For this portrait of a long-haired dog, use a cartridge paper with a slight 'tooth' and a 2B pencil. Working from light to dark, lay in the mid-tones, taking care to leave the highlights on the nose and the eyes.

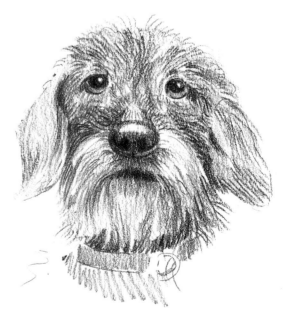

2 Lay in the darker tones using softer pencils, keeping the pencil marks as crisp as possible. Watch for shadows cast by the outcrops of long fur, around the mouth, for instance - this will suggest depth and form.

1 Start with an outline drawing of the gorilla with a 2B pencil on smooth board, simplifying the head into geometric shapes in order to capture its solidity. Then start to lay in a mid-tone 'wash', working lightly with long lines to suggest the character of the animal's fur. Remember the forms beneath the fur – if you forget them, the result will be flat and unconvincing. Look for the light falling across the form, and for the areas of dark tone. Notice that the gradations between the two are very subtle.

2 Once the basic shape and form of the gorilla, and the general direction of the hair has been worked, start to work the tone with more detail and contrast. Deepen the areas of shadow, using fluid pencil strokes to add to the texture. Add finer details around the face with smaller strokes and touches of tone. All the pencil strokes should go towards describing the form and texture of the animal, and even the wisps of straw that it is sitting on reflect the glorious texture of the rough, hairy coat.

LONG HAIR IN WATERCOLOUR

It is important to be conscious of the underlying skeleton and musculature. Mark out the form lightly in pencil or a thin wash of paint – ultramarine is ideal, as it disappears when painted over. Do not get too involved in drawing detail at this stage, there is a danger you will become too absorbed with the drawing and will end by 'colouring in' the animal. Lay in the lightest tone and allow to dry, then work over the form in your medium tone. With long hair, the tonal changes are more abrupt, so you can lay in your medium tones as distinct areas, with less diffusion. When dry, put in the shadows and details.

'Dry-brush' is an effective technique for rendering long hair. You will need to use a rough or semi-rough watercolour paper and a stiff brush such as a hog-hair oil-painting brush. Start by laying in a light wash all over the animal for a base colour. You can then drop in a medium tone while the first wash is still wet – this will cause the second colour to diffuse into the first wash. Alternatively, allow the first wash to dry and then add the medium tone.

When the surface is dry, mix the colour to be dry-brushed. Use less water and more pigment than usual – but don't make it *too* thick. The secret is to use less water, load a brush with wash, then blot off most of the colour so that the brush is nearly dry. If you then drag the brush across the surface of the paper you will create a good 'hairy' effect. Work in

the direction in which the hair grows and don't paint all the fur in detail, just at key points.

Pen and ink can also be used to strengthen a watercolour, and as a technique on its own for drawings of long-haired animals.

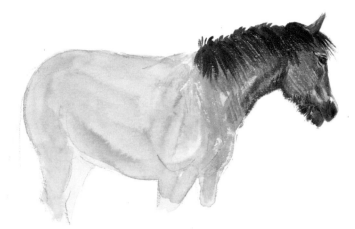

■ **Above: I used a dry-brush technique for the rough coat and mane of this pony, washing in the light and mid-tones using mixes of yellow ochre, vermilion and burnt sienna. For the darks on the nose and eye I used a mix of Antwerp blue and burnt umber. When all was dry I loaded a stiff-bristled, hog-hair brush with the dark mix. I blotted off the colour so that the brush was almost dry, and dragged it across the painting to create a heavily textured effect.**

1 **For a study of this small dog use a rough paper, watercolour and coloured pencils. Start with a drawing in 2B pencil, indicating the broad shapes and volumes, as well as the main directions of the hair.**

2 **Lay in a wash of yellow ochre for the light areas with a blue-lavender wash for the shadows mixed from burnt sienna, cobalt and rose madder; a combination of warm and cool colours such as this helps to model the form. Under-paint the eyes and nose in blue to give a subdued highlight to both features.**

3 **For putting in the darkest tones use a combination of indigo, french ultramarine and burnt sienna. Then add all the final highlights and details using coloured pencil.**

■ Right: This shaggy little pony was lightly sketched in pencil, then I drew on top in pen and ink, blotting the ink around his nose with my finger. I masked off the background with pieces of scrap paper, then spattered ink near his feet by drawing an old brush across a toothbrush loaded with ink.

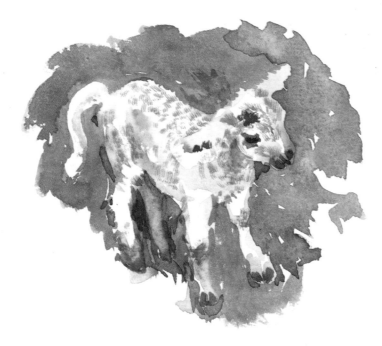

■ Above: For this painting of a lamb I used dry brushwork on top of a colour wash. Notice the way the texture has been used to describe the lines of the body.

■ Right: Here I have shown how the image was built up by completing the left side of the kitten only. I started by laying a wash of french ultramarine with a touch of vermilion – you can see this on the right of the painting. On the left I have laid in the dark parts of the fur with ultramarine mixed with a little burnt umber to give a blue-black. I used coloured pencil to add whiskers and fur where they caught the light.

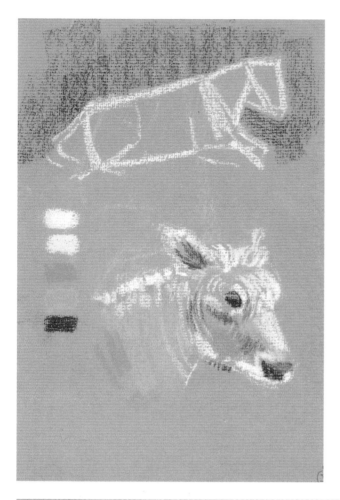

LONG HAIR IN SOFT PASTEL

Effective marks can be built up with pastel to represent both the texture and colour of long hair or fur.

Soft pastels are capable of extremely delicate and sensitive effects, yet they can also be strong and rich. Their chalky texture makes them very suitable for rendering rough textures in glowing colours. Used on top of a dry watercolour they can add a textural quality and enhance the image.

The choice of paper colour is important, and generally it is a good idea to choose a paper that is the complementary colour of the predominant colour of the animal. The paper can also give tonal value to the drawing.

1 Using a mid-tone Ingres paper, establish the outline of the cow with soft pastel. Indicate the background colour, and start to build up the drawing with hatched lines, using a limited palette of warm and cool colours.

2 Allow the texture and colour of the background to show through. Build up a crunchy impasto where the back of the cow catches the light. Use a creamy white for the areas nearest the light. Pure white is rarely seen, because sunlight warms it.

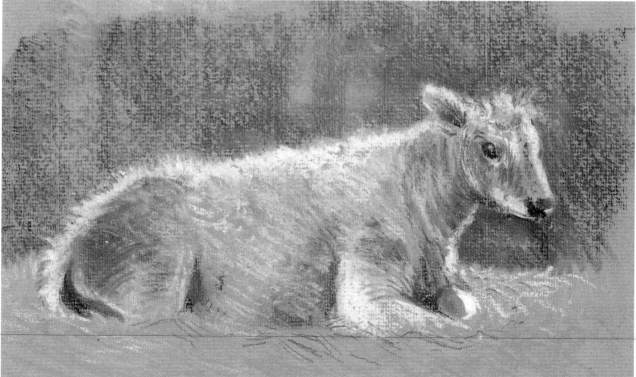

PATTERNED COATS

The patterns on the skin or hair or feathers of an animal or a bird are extremely useful in describing its form. Whatever did we do before Friesian cattle! If you observe them carefully, the way the markings on an animal lie across its skin or coat, and the way the light affects its surface, give you a better chance of producing an accurate drawing. Things to watch for are the way the pattern 'folds' around the form; the effect of light on the form – where it is bright and where it is in shadow; and the individual colours of the light and shadow areas.

When you are drawing or painting a patterned coat you are looking at local colour (the actual colour of the animal) and tone (the lightness and darkness of colours caused by the effect of light). Study the coloured part of the coat in the light, and note how it darkens in the shadow; even black looks different in light and in shadow.

PAINTING PATTERNED COATS IN WATERCOLOUR
Start by laying in a first wash of a light tone – the white of the paper may be *too* white for the highlights on a white animal. If the animal is in sunlight you may need to lay an ivory wash (raw sienna or yellow ochre paled with lots of water) over the whole of the coat to create a warmer 'white'. Leave to dry.

Look at the areas where the light is shining on the dark patches of the coat: decide what the colour is, and lay that down over the whole of the dark patched

1 Make an initial drawing of the Friesian cow in 2B pencil, using simplified geometric forms.

2 Lay in the mid-tones, working lightly. Half-closing your eyes will help you to concentrate.

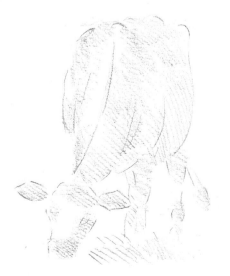

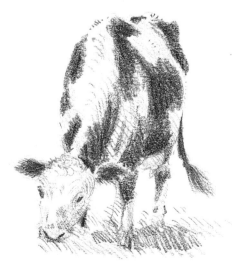

3 Use hatched lines to lay in the light parts of the dark patterning and the dark parts of the light elements.

4 Block in the darkest patches, curving them around the form so they appear to be an integral part of the animal.

1 Use a pencil to draw
the basic form of the
piebald horse and rider.
Mix a pale wash of
yellow ochre and apply
it over the area of the
horse's body. When dry,
apply pale washes of
grey mixed from french
ultramarine and burnt
umber on the patches
to be coloured. As this
dries, apply a darker
tone of the same mix.
Mix a pale lavender
blue from ultramarine
and a little rose madder
to add to the shadow
parts of the white areas
of the horse.

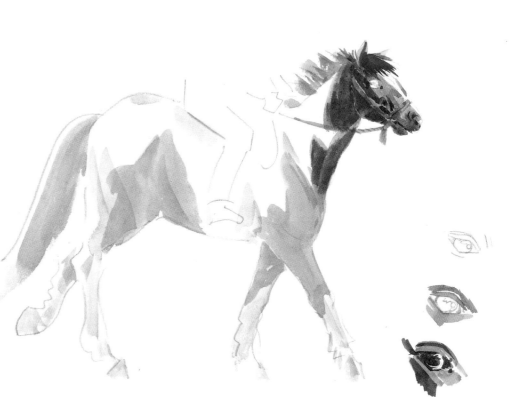

2 Apply the black on
top in the relevant area.
Pay attention to the
position of the high–
light on the eye. Apply
a little more yellow
ochre to the feather
(the long hairs) on
the legs.

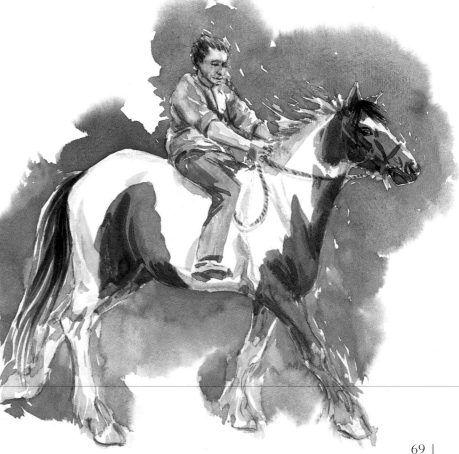

1 Apply a wash of pale yellow ochre all over the body of the tiger except for the white areas – these have cobalt blue in the shadow areas. When dry, apply another stronger wash – gamboge and rose madder mixed to make a soft orange. While still slightly damp, put in the stripes with a mix of burnt umber and french ultramarine so that they bleed softly into the orange. The stripes are affected by perspective and will appear foreshortened in some areas.

Note how the eye looks more effective when the cast shadow of the top lid is applied – it prevents that 'staring' look.

2 Fur is only noticeable when placed against another colour or tone, so you do not need to paint all the fur in detail; if you describe it on the edges of the form where it shows against the water, you will create the required effect with great economy.

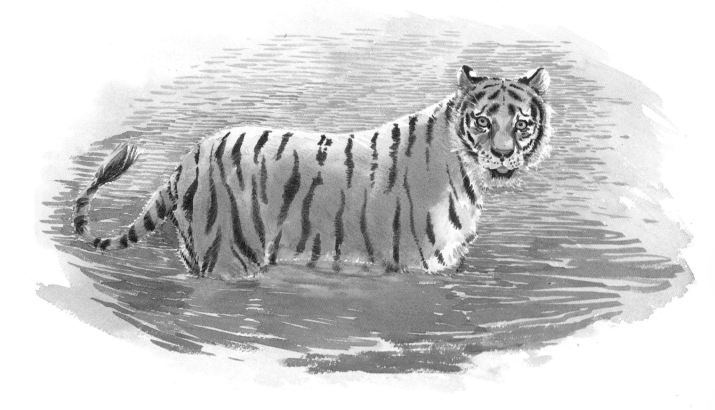

area. When dry, add the shadow colour to the white parts, and the shadow part to the dark patches. Complete by adding the final details.

If the animal has a heavily patterned coat such as a leopard or tiger, look very carefully at the way the pattern is distributed across the body. Detailed photographs may help you understand what you are seeing. Remember that the pattern will be affected by perspective.

Beware of overworking details. When we look at something we focus on a salient feature and are only peripherally aware of the rest of the object. If the entire picture is painted in detail it will look excessively 'busy' and this will be distracting, because the eye doesn't know where to focus. Moreover, if pattern is too carefully rendered it will look flat, unreal and dead, more like a wallpaper pattern than that of a living thing.

EXERCISE: *Paint an animal with a strongly patterned coat. Place it against a light or a dark ground, making the background contrast with the markings on the coat. Always try to place a light subject against a dark background and vice versa, as this gives greatest contrast and impact. Thus a light-coated animal will appear more effective when placed against a dark green field, or a dark shadow. A subject's surroundings also describe it: for example, a white chicken would be lost against a white background, but against a darker tone it will stand out well.*

SCALES

If you should wish to draw and paint reptiles the method of working is the same as for any animal's coat – you work from light to dark. Highlights usually take the form of a sheen along the body – notice the way this follows the line of the coils of a snake. Markings tend to be dusty-looking and subtle in colouring. Emphasize the snake's face, particularly the eyes and their relationship to the mouth. Snakes' mouths open surprisingly wide – so that they can eat very big prey.

If you are lucky you may have access to a snake. Snakes that are kept in glass tanks make wonderful models, especially at low temperatures when they become torpid. I once spent two hours drawing a snake and he didn't move except to put his tongue out once. I am actually afraid of snakes, so for me to draw them is a sort of cathartic exercise!

■ **Below: It is not necessary to put in all the scales in detail; just draw those that are most noticeable and the rest will be implied. Work from light to dark, laying in the medium tones, leaving the lights, and applying the darkest tones last.**

FEATHERS

Birds have different types of feathers located on different parts of their body, and all arranged in complex patterns. Some feathers, such as the down on the chest, keep the bird warm, while others aid flying and gliding. Feathers are arranged like the tiles in a roof, each one overlapping its neighbour to present a smooth surface that enables water to run off it easily.

Rendering feathers is a little like rendering short hair in that they present a smooth surface to the light and produce soft highlights. Birds often have strongly patterned or coloured coats, but don't think that by describing this accurately you will produce a successful drawing or painting. If you concentrate on the pattern alone, the result will be flat and lifeless. Concentrate on suggesting the whole form in terms of light and shadow, and *then* add the pattern, if necessary.

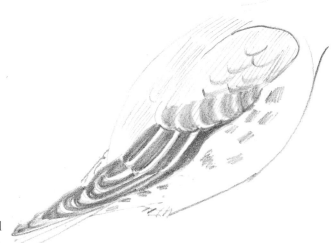

■ **Above: A simple pencil sketch of the feathers on a bird's wing.**

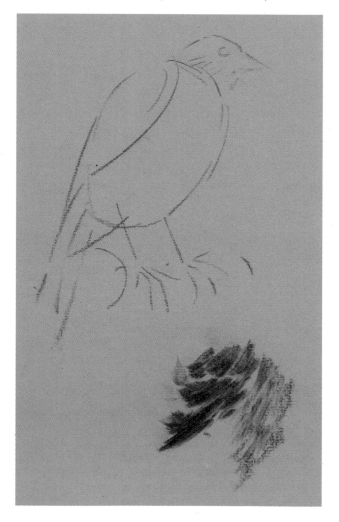

1 **Loosely mark out the jackdaw using a tilted egg shape for the body.**

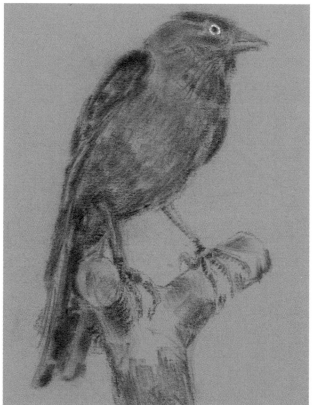

2 **Apply charcoal in the direction of the feathers. To create softer tones, smudge it gently with a shaping tool (a trowel-shaped piece of rubber mounted on a brush handle) or a pointed putty rubber. Apply the darks with firm strokes and highlight the eye with white chalk pastel.**

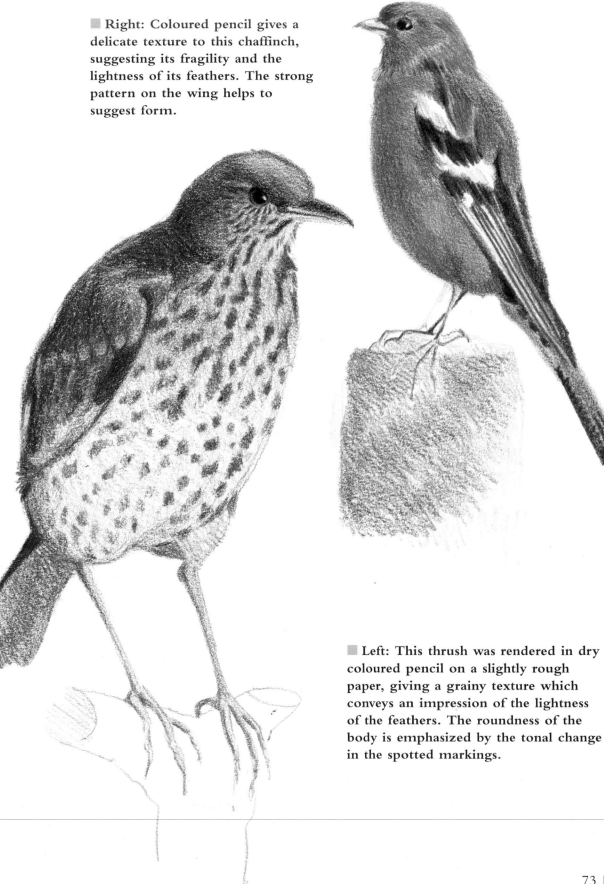

■ Right: Coloured pencil gives a delicate texture to this chaffinch, suggesting its fragility and the lightness of its feathers. The strong pattern on the wing helps to suggest form.

■ Left: This thrush was rendered in dry coloured pencil on a slightly rough paper, giving a grainy texture which conveys an impression of the lightness of the feathers. The roundness of the body is emphasized by the tonal change in the spotted markings.

■ **Left: Felt-tip markers force you to be decisive with a drawing. They are used here to give a lively rendering of the plumage of some poultry.**

■ **Right: I painted this colourful robin in watercolour and used pencil to define the details of the feathers.**

EXERCISE: *Make sketches or painted studies of birds and animals using only one neutral colour in different tones to describe the shadows and texture.*

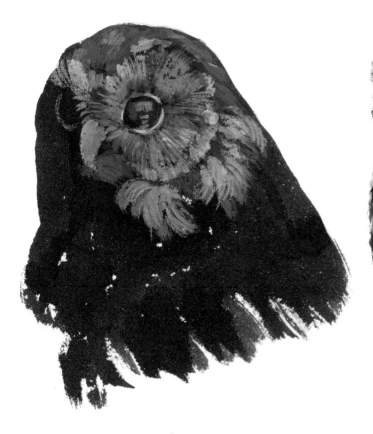

■ Above and right: For this owl I used gouache, an opaque form of watercolour. First, I painted the bird in silhouette in black waterproof ink. Then, using a medium-sized squirrel brush loaded with thickly mixed gouache, I began to apply the paint, lifting the brush to get a 'feathery' look.

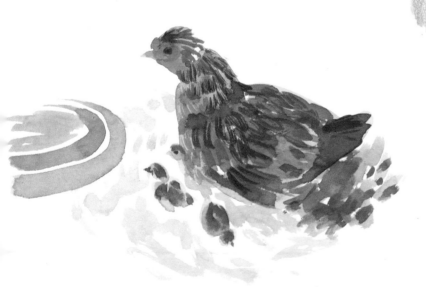

■ Left: A rapid watercolour sketch of a nervous broody hen made with decisive textural brush strokes.

Capturing movement

Successfully conveying the feeling of movement and life is the most important aspect of animal art, because it is this quality which gives an animal its uniqueness, beauty and character: a painting must capture the essential quality of that animal and above all it must make it look alive. It is, however, the most difficult thing to achieve. You will not capture this 'aliveness' by painting every hair, whisker, or feather – it is more elusive than that. So how is it done?

OBSERVATION

Achieving movement and 'life' entails observation: this is the major element in all drawing and painting, and particularly with regard to animals. Spend time watching the animal, even though you may be dying to get on with the drawing. Note the way it moves and its typical resting pose. Consider it carefully: what sort of character does it have? Is it bold and fierce, or shy and timid? A rabbit, for example, is a timorous creature whose survival depends on outrunning the predator, and its most usual pose is the crouched 'flight' position, a pose which seems to encapsulate its character. Contrast this with a cow which is a fairly sedentary animal: when it is not grazing it stands or sits in a way which reflects this quality.

Run through everything you know about the animal. Is it graceful, agile, swift, nervous, or is it slow, lumbering, peaceful? Imagine yourself becoming that animal, jumping, running or grazing (not as silly as it sounds as long as you just imagine it). In this way you will be able to get into the character of the animal – it's a bit like actors getting inside their roles. You will be able to capture the character and liveliness of your subject so that your work will be more than a mere record of what you see.

It helps if you like the animals you draw because you will have an empathy with them. But a word of warning: if you become too emotionally involved you may lose your objectivity and risk producing an image which is sentimental. As long as you remain detached and respect the animal's individuality you will permit the subject to 'speak', and an honest rendering will communicate more to the viewer than any attempt to make it appear fluffy or cute. Whereas if you interpose yourself between the animal and the viewer your picture will say nothing about the animal

■ **When not grazing or standing, cattle are often to be seen lying down – apart from the odd frisky steer, they tend to be quiet, sedentary creatures. In a landscape painting they introduce a feeling of calm and peace – cattle and sunsets go together.**

and too much about you. Be aware of these potential pitfalls and you will produce drawings and paintings which are informed, convincing and honest.

Check the lines of your animal: are they soft and graceful such as a rabbit's, or hard and angular such as a goat's? Is the animal a blend of both, and if so, *where* are these lines hard and soft? If you look for and manage to reproduce these qualities your work will be expressive.

Sometimes you need to simplify and exaggerate to create an effect.

■ **Below: Herbivores spend a lot of the day grazing, so their most typical pose is head down. Remember that the end of the nose must be level with the feet.**

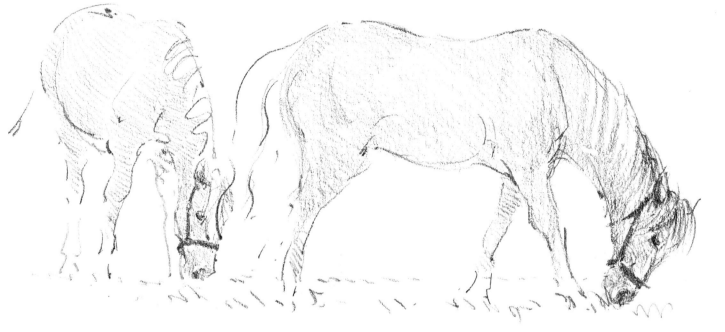

■ **Right: Rabbits often adopt this poised-for-flight attitude: they are shy, timid creatures, whose defence is to run quicker than the predator. Try to draw the animal's typical stance – it will convey its character.**

TRAINING YOUR VISUAL MEMORY

Few animals stay still long enough for you to capture a pose – so what do you do, where do you start? The ability to simplify and to identify the essential (salient) lines is very important because these will allow you to capture an impression of the animal quickly.

One method is to watch the animal moving for a few minutes before you draw. Close your eyes, then open them quickly, and then shut them again. Now try to remember what you saw of the movement. What you remember seeing will be what you must draw, because what you observed will be the salient feature, whether it is the powerful, graceful line of a deer's back, or the flapping shuffle of a large, round pig. Practise this technique on subjects such as landscapes, people, buildings and flowers.

Joseph Crawhall (1861–1913), one of the 'Glasgow Boys', looked at his subject for an hour before going away and drawing it. He taught himself to scrutinize his subject so intensely that he was able to draw from memory. This is difficult, but if you practise this intense way of looking before you start a drawing, you will find that your powers of observation and your ability to draw will improve immensely.

■ **Right: Expressive line gives rhythm and grace to a form. Look at the animal and try to analyse where the curves occur, and where the angular lines are. In the young goat the lines follow the watchful pose and originate at the place where the weight is supported, above the front legs. Observe the sinuous curve of the neck in front of the shoulder, and the curve of the backbone following down behind the shoulder. The head is slightly lowered and this causes the shoulder blade to arch above the backbone. Note also the tension in the stretch of the back legs as the animal strains forward to look.**

■ **Below: This pig is a mass of curves, and if you can capture these salient curving lines then you capture the character of the animal. Some pigs have big ears which point forward and flap as they walk – try to capture this flapping motion.**

■ **Right: This dog was rolling as I was trying to draw him, and all I could be sure of was where his paws and ears were. For the rest of the body, I followed the sweeps and curves of the hair which indicated the form.**

EXERCISE: *To identify the salient lines of an animal, look at your subject, close your eyes, open them, then shut them a second later: what you saw in this one-second look will be the salient lines of that animal's position. Try to get those down as quickly as possible. This is the technique I used to draw this deer (left), which was rendered with a few expressive lines and smudged tone that gives the animal solidity.*

■ **Right: This dog was a very lively creature and almost never stood still – he seemed a mass of movement, with a lot of wagging tail and wriggling back activity! I used a series of undulating curves with a soft pencil in my attempt to commit him to paper.**

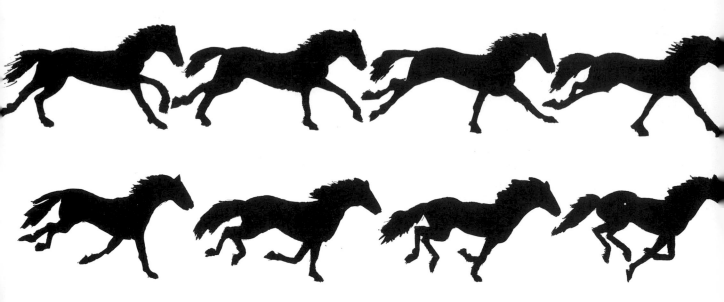

PHOTOGRAPHY

Before photography, artists had to rely wholly on observing with their own eyes and then had to translate that into a pictorial representation.

The way an animal was portrayed depended on its place in the culture of the period. In the prehistoric cave paintings at Lascaux in France, running animals were portrayed with an energy and life which was lost by subsequent civilizations. The painters of Lascaux probably hunted these animals and therefore needed to observe them closely, and it was this familiarity which gave the works so much life.

In the eighteenth and early nineteenth centuries artists painted 'flying' horses with all four feet strangely outstretched. They probably wanted to illustrate the fleet paces of the patron's prize racehorse, or the speed of the coaching company.

It was with the invention of freeze-frame photography by Eadweard Muybridge (1830–1904) that the movement of horses was understood. His work showed that when horses are cantering and galloping they draw their legs together and that at one stage of the movement all four feet do actually leave the ground together, although not in the way earlier artists envisaged.

Today, there is a vast range of cameras and film available, which can be used to capture a moment in time and to give you a permanent record of an action, from which you can get a clear understanding of the form and characteristic of an animal in motion.

Recording animals on a camcorder can provide useful reference, enabling you to play back the video

■ **Above: Eadweard Muybridge (1830–1904) used freeze-frame photography to investigate scientifically the actions of animals. Photographs are useful for capturing movement accurately, but should be used with great care.**

tape of a particular action as often as you want so that you become familiar with the animal's habits and movements. The pose can also be held on freeze frame while you make a drawing at your leisure.

A camera can be used to take snap shots of your chosen subject. Take a series of photographs at different points of the action that interests you, from different views, both long distance and close up. This will provide you with good reference material and help you to understand the animal's movements.

It might be supposed that since the invention of photography, artists have been able to work more easily and accurately, but problems occur when the painter works blindly from the photograph, bringing no knowledge beyond that visible in the print. Beware, for photographs can be very misleading. Photography can distort perspective, flatten distance, it cannot convey the subtle change in tones that the human eye sees, and it is often colour-biased (slide film is more reliable than colour print film).

Used as back-up reference, however, photographs are extremely useful, but they should always be combined with first-hand observation and sketches. Photographs can also be surprisingly inspirational for ideas for composition.

FORM

Capturing an animal's form, its character, attitude, or a fleeting action can be a daunting prospect, but the answer is to remember to simplify what you see, interpreting it as manageable shapes. In Chapter 2 I discussed ways of reducing what you see to simple geometric shapes; if you are drawing a sitting cat, for example, you will find it helpful (and quick) to draw it as a series of triangles. By starting in this way you will give yourself a 'peg' on which to hang the form – ideal when you don't have a lot of time in which to catch a pose.

Also vital to any understanding of an animal's form and movement is anatomy, which I also discussed in Chapter 2. Even a rudimentary knowledge of what goes on under the skin will improve your work. When drawing movement it is crucial to understand how the limbs move. The articulation of the body can be understood by the position of the three great divisions. Careful observation of these critical lines will enable you to record the animal's stance quickly and accurately – helpful when you are out sketching animals as they move.

■ **Below: Whatever position the animal adopts – apart from fully frontal, or rear – it is possible to see the three great divisions, even when it is lying down. Indicate these curves at an early point in your drawing.**

■ **Above: To draw quickly and accurately, reduce the animal to a series of simple geometric shapes. This system will help you understand the forms of a moving animal more easily. You can erase the construction lines afterwards.**

CATCHING A POSE

There are a few practical hints which will help when you are working out-of-doors, directly from the subject. Use a large cartridge pad. Start drawing the animal, then when it moves start another drawing, and do further drawings until your sheet is full. Eventually the animal (or possibly another one) will return to each of the poses you have started and you will end up with a sheet of drawings of the animal in different positions. Inevitably some of them will be better than others but this is normal. Professional photographers work in a similar way, shooting a whole reel of film of the same subject in different positions, and selecting the best for printing up.

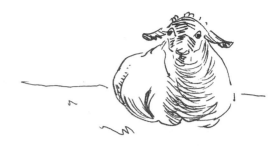

■ **A flock of sheep provides an ideal subject for building up a number of drawings of different poses on a sheet of paper. Use pencil or pen and work quickly and decisively, catching the salient lines of the pose, or roughly indicating broad areas of tone.**

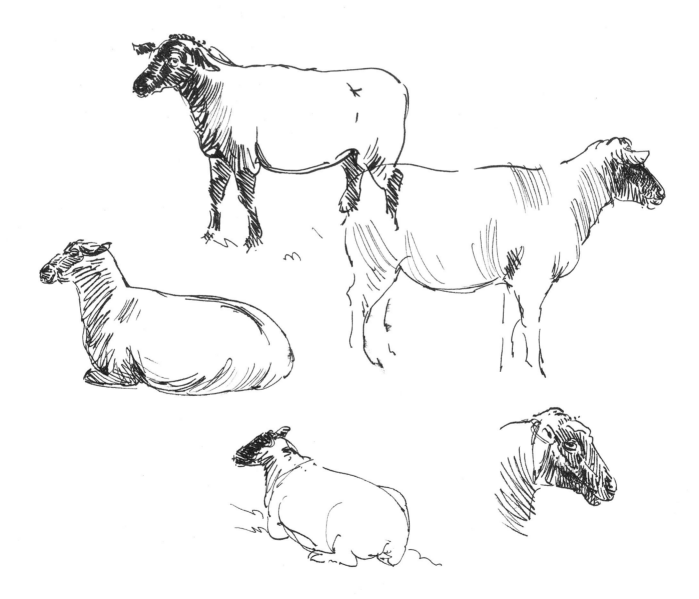

DOMESTIC MODELS

A domestic pet makes a good subject, although there are some points to bear in mind. For example, don't try drawing your pet after its main meal as it will probably want to sleep; this is fine if you want to draw a somnolent animal, but useless if you want movement. Moreover, it is often difficult to be an impersonal observer of your own animal because it will probably want to inspect what you are doing or to play with you. Try to find it something more absorbing to play with or draw with someone else in the room to divert the attention away from you. Sometimes having the television on helps – my kitten loves football matches! Don't sit too close: about two metres away is a good distance from which to observe form.

Arrange the lighting so that it falls clearly from one direction; the light and shadow thus created will help you to see the animal's form. Start by making an initial sheet of studies because this will help you to become familiar with the form, and provide you with a choice of poses. If you are going to paint a picture, take a photograph of the pose you select to supplement your drawings. It will be a useful *aide memoire*.

■ **Above: My kitten Guy loves football matches on television, and these will keep him still for a little while enabling me to capture him on paper. The back of an animal can be as expressive and interesting as the front. This study was painted on Not watercolour paper using a wet-on-wet method.**

■ **Below: Kittens are rarely still except when asleep, but this large soft toy kept Guy going for several minutes before he decided he had won the battle. When drawing at speed try not to look at your drawing too often, but translate what you are seeing onto the paper without taking your eyes off the subject. This may sound impossible but it does work – after some practice!**

PERSONALITY

Surprisingly it isn't the eyes, nose and mouth that establishes a likeness in portraits of animals or people, but the way that light falls across the form and the shadows which are cast by bony structures and other tissue. (See Chapter 3, Developing confidence, for more information on eyes, ears, noses and mouths.) The only exception is when working on animals and birds in close-up, when the eye needs to be rendered accurately. The eyes are the darkest thing in the face (even if the animal is black) and the most expressive part of the close-up features.

■ **Right: The bone structure and shape of the skull will convey a likeness more readily than the features on the face, except for the eyes which are the most expressive part of the face; eyes should therefore be studied carefully. Note that goats and sheep have lateral pupils (they lie sideways) a feature which gives them a curious appearance.**

■ **Above: Cows have large liquid eyes surrounded by curves of folded skin which help to give a languorous expression to the face.**

■ **Left: This cat was looking thoughtful, and his eyes look even more expressive because their colour stands out against the dark fur. However, always make sure the eye pupils are the darkest colour – even on a black animal.**

EXPRESSIVE LINE AND BRUSHWORK

When drawing movement, use as few lines as possible: you must look carefully to see which are the important ones, and which describe movement. Important lines often occur at the three great divisions. Study the attitude of the head and neck, because each species of animal has a characteristic head and neck position. A horse, for example, has a curved crest of a neck, with the head resting at an angle to it. In foreshortened poses, where the animal is facing you, for instance, check to see how the head is positioned in relation to the body. The pig has a rather short, fleshy neck and its head appears to have been stuck straight on and given a push to settle it into position!

■ **Try to render form in as few lines or marks as possible – this will create a feeling of life and movement. And when you add shading or colour try not to overwork it, as this will deaden the subject.**

■ Above: Sometimes studies can be regarded as 'finished' works because they capture an attitude, a sense of life, and this spontaneity might be lost if the study was developed any further by the artist.

■ Above: Using line to emphasize certain parts of the form will allow you to reduce the drawing to bare essentials, as in this study of a poodle.

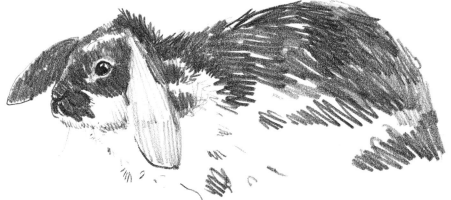

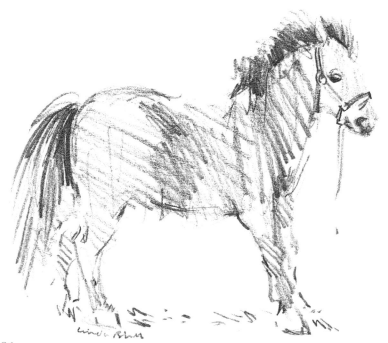

■ Above and left: Use scribbled lines for speed when sketching. This gives life to the subject and encourages you to draw quickly to capture the pose.

ANIMALS IN ACTION

When you are sketching a moving animal on location you must work fast to get the information down quickly. Scribble on tone to suggest shadow areas and darker colours. Make the lines follow the direction of the hair on the animal's coat – this will give the drawing great energy and movement.

Another useful technique is to draw the subject, and as the animal moves, draw again over the top, leaving your original lines intact; this will give an immediate impression of movement in the animal. The lines may look a little confused but the work will have great vivacity.

Try to discern the rhythm of the animal's movement, something which derives from the way the feet move in sequence. Watch how the head of a horse, for example, nods as the animal walks; this is caused by the action of the shoulders and back which are being impelled by the leg action.

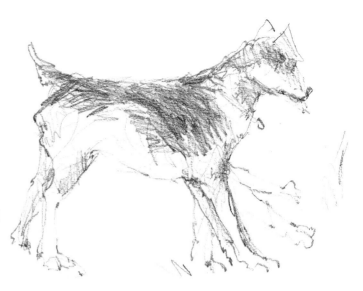

Above and below: Draw th animal each time it moves, on the same drawing – the result will be lively and immediate.

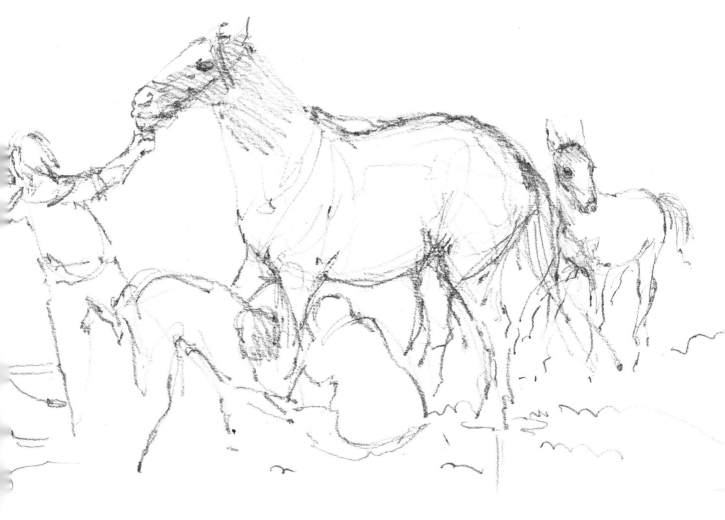

■ Right: A sense of speed is conveyed through the hatched lines of soft pastel in this drawing of a horse and rider. (Note that this is 'left-handed' hatching.) The drawing is strongly directional, the hind legs are only suggested in a few strokes and the mane and tail fly out in the wind.

■ Below: The scribled drawing of the horse and rider expresses the energy of the form, and the suggestion of the water through which they are splashing conveys a sense of lively movement.

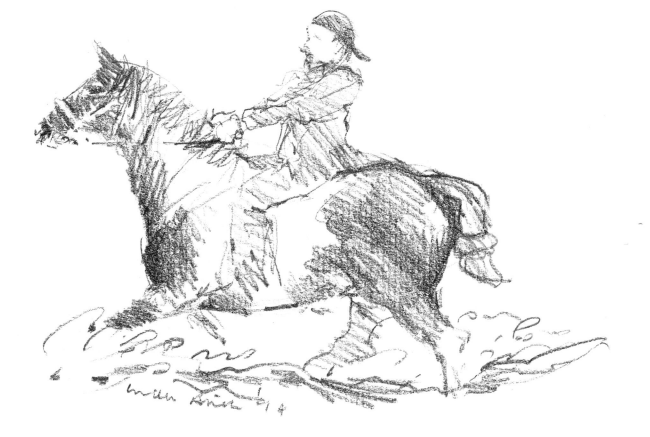

When working in line or colour (here I used marker pens), decide which parts you want to emphasize, then detail those and render the rest of the picture in less detail. I decided that the horse and the extraordinary trotting gait of its legs required more attention than the rest of the body and the driver behind in order to emphasize the movement and create a feeling of speed. In real life you would see a speeding blur.

EXERCISE *Drawing animals from television programmes such as race meetings is an excellent way of developing your visual memory and capturing movement. If you have a video, use the freeze-frame button to record animal poses in wildlife films.*

TIP: *When painting movement, include plenty of 'lost' and 'found' edges – edges which are clear and emphatic ('found') and edges which dissolve into the surrounding paint ('lost'). This combination will suggest movement.*

BIRDS

Capturing birds in flight requires the same knowledge and skills that you need for drawing other animals in action. Observation is clearly very important, so watch wild birds in flight as much as you can (a pair of binoculars would be very handy). Birds are often seen silhouetted against a light sky, so their profile in flight is very important and you need to recognize and become familiar with their distinctive flight patterns. Books on ornithology are full of information that is valuable to the artist; they also usually give airborne silhouettes for identification, besides information on habitats.

A study of the anatomy of birds will of course help, and caged birds or ground-dwelling domestic fowl will give you the opportunity to observe birds at closer quarters.

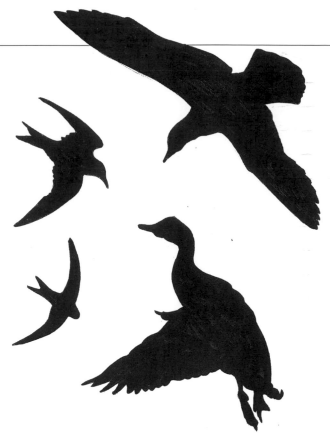

■ **Above: Familiarity with bird profiles is useful when drawing and painting birds. Since birds in flight are usually seen against the sky, this tends to make their forms appear darker, thus making the shape more apparent.**

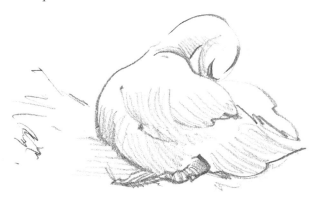

■ **Larger birds such as swans and turkeys are good beginner subjects as their movements are slower than those of smaller birds. This makes them easier to observe and also gives you more time to capture a pose.**

■ Domestic birds can be excellent models. Sitting on a perch, they are easy to observe, and provide good practice before you try painting their wild cousins. A light wash captures the basic bird shape, with details then added with subsequent layers of wash.

■ Watercolour was the perfect medium for capturing the light, fluffy texture (and character) of this delightful little chick. The background wash predominates, with additional washes applied sparingly and growing subtly darker.

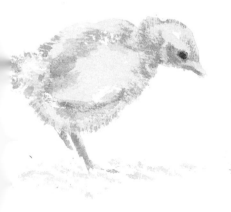
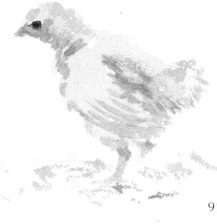

Making pictures

There are a great many things to think about before you even start a picture. The most important question to ask yourself is 'Why do I want to paint this picture?' The answer will provide the kernel of the image, around which all aspects of the composition can be structured. Remind yourself, from time to time, of this initial inspiration. By orchestrating the composition and colour so that they carry this theme, you will produce an image that has impact, coherence and integrity, and which will communicate effectively with the viewer.

You don't have to make a grand statement. One portrait may focus on an animal's physical beauty and elegance, while another brings out the subject's strength and energy. You may want to draw the viewer's attention to the grace and vigour of two dogs running, or to express your enjoyment of cattle quietly grazing in a pastoral landscape. But whatever the subject and the inspiration behind it, it must be done well.

In this chapter I consider the procedures involved in researching and making pictures in watercolour. The process starts with observing, studying and sketching animals; then you have to find a subject and a theme; then plan and construct the picture. The planning or 'composition' of the picture is sometimes overlooked in the enthusiastic rush to record the subject or experiment with a technique. However, flamboyant brushwork or minutely rendered detail do not necessarily make successful paintings, and many technically accomplished images have no 'heart'.

More paintings have been spoiled by lack of planning than by being badly painted. You might paint a splendid head of a dog, but if you place it too near the bottom edge of the paper it will look as though it it is 'dropping out' of the picture and the image will be unsatisfactory. This sort of problem can be avoided by a little forethought, and a few quick 'thumbnail' sketches: tiny pencil drawings in which you can work out proportion, placing and tonal relationships in order to find the best arrangement for the subject. They take seconds to do, and the more problems you can resolve in this way before you start, the easier and more enjoyable the process will be, and the greater your chance of producing a successful painting.

There are some traditional compositional devices which have been shown to work, and as you work, you will discover how to use these ideas in the way that suits you and your subject best.

TIP: *A viewfinder made from a small piece of card is an invaluable tool for 'finding' a composition. It works like a camera viewfinder. The nearer to the eye it is held the more you see, the further away you hold it the less you see; it can help you to decide which part of the scene to include in your painting. Place marks half-way along the sides, or use elastic bands to form a grid. Draw a rectangle on the paper you are working on which corresponds to the proportions of the viewfinder and mark on the reference points to help you make an accurate drawing.*

Before you start a painting, explore different compositions in a series of small thumbnail sketches. Try different ways of placing the subject on the support, and explore the possibilities of landscape (wide) and portrait (upright) formats. Decide what you want to include and what you want to edit out, and consider how to distribute the areas of tone.

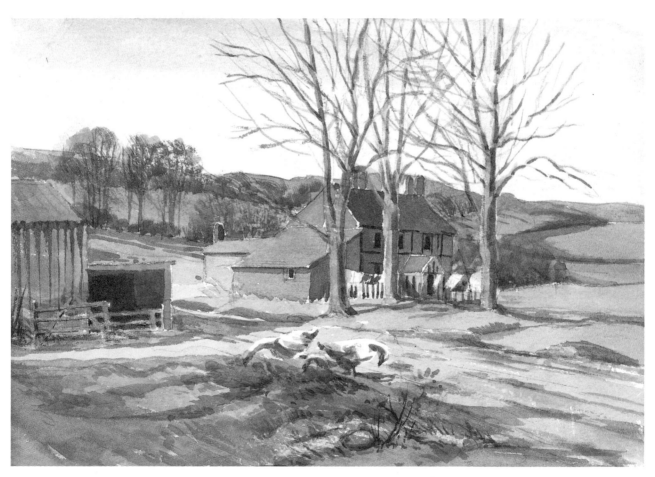

The road leads the eye towards the geese and the house at the focal point of the picture. An illusion of depth is given by setting a dark foreground against a lit middle distance, with swathes of shadow and light in the far distance. The play of warm colours against cool colours adds to the atmosphere, and emphasizes the sense of distance.

SOME DOS AND DON'TS

There are some generally accepted rules of composition which you may find helpful – although remember, all rules can be broken. Having decided on your subject matter, you will have to make decisions about the arrangement and placing of the various elements. You will find a viewfinder a very useful tool for selecting the most successful and suitable view. It allows you to isolate a part of the scene, and to decide how much or how little of it you want to depict. Try out different ideas as thumbnail sketches. Each subject has its own considerations, and you will make discoveries and decisions as you work.

PLACING

The edge of the picture area, and where the animal is positioned in relation to it, is important. For example, if you place the animal too close to the bottom of the picture it will look as though it is falling out of the 'frame' altogether (1); and if it is placed to one side of the painting facing outwards, it will look as though it is leaving, and the viewer's eye, too, will be led out of the picture.

Avoid placing the subject in the dead centre of the picture (2) or repeating important elements at the same scale (3) because this creates an image which can be symmetrical, static and boring. Generally, it is better to place important elements slightly off-centre. However, this is not a hard-and-fast rule, and there are occasions on which you may wish to break it.

If you are only including part of an animal in a painting – in a portrait, for example – don't crop the subject at its joints; if you do, it will look 'amputated' and awkward (4). Extreme foreshortening can result if awkward and ugly shapes, so look out for this especially when working from photographs (5).

Unfortunate juxtapositions of animals with the position of background subjects can give strange optical illusions (6).

Watch for the lines created in the picture plane. Parallel lines can weaken a composition (7), especially if they are too close to the sides or bottom of the picture area.

FOCAL POINTS AND GROUPING

The viewer's eye needs to be guided into and through the painting, towards a focal point, and in this respect it is useful to have a good lead-in: a path, a stone or two, or a clump of plants, strategically placed to draw the eye into the picture area (9).

1 The subject is too low on the support and looks as if it is falling out of the picture.

2 Placing the subject in the centre of the picture can have a deadening effect on the composition.

3 If this picture were cut in half, the two halves would mirror each other.

4 Try not to amputate animals at their joints.

5 Avoid the awkward shapes caused by extreme foreshortening.

94

If you are painting a landscape and want to show animals in the distance, don't render them as scattered dots, but group them carefully so that the eye reads them as a flock, a herd or a group of animals **(8)**.

TONE AND COLOUR

The arrangement of the areas of tone within your painting is important, so look for the blocks of light and dark. You should also consider the arrangement of colours within the picture. You know that red and yellow tend to 'advance' while blue tends to 'retreat', so use these effects to emphasize or subdue elements in the picture. Colour can also be used to create mood and atmosphere.

In the past, artists often created the illusion of depth in a painting by setting a dark foreground against a lit middle distance, with swathes of shadow and light in the far distance. You will see this formula in the paintings of Claude Lorraine (1600–1682) and Nicholas Poussin (1615–1675) and it is a system which is useful for any painting.

TIP: *A system for achieving an harmonious division of the picture area involves dividing each side into three equal parts, and creating a grid of nine sections. Where the lines of the grid intersect are called the 'four key points', and important elements of the painting may be located on these to good effect. Here, the eye of the ewe and the eye of the lamb are located on these points.*

6 **The horse appears to be glued to a tree! Place background objects carefully.**

7 **Strong parallel lines do not hold the composition together.**

8 **Animals in the distance should be grouped to make them look like grazing animals, not scattered dots.**

9 **A good lead-in encourages the eye to move into the picture and travel around it.**

PERSPECTIVE

Even though animals may be the focus of your subject, they should sit naturally within their surroundings and not 'leap' out at the viewer (unless this is a deliberate intention). Animals, like everything else, must be made to conform to the rules of perspective, and in a picture they will appear to become smaller and paler in colour as they recede into the distance.

Colours are also affected by distance, a phenomenon called 'aerial recession': as a colour recedes into the distance, it appears lighter, tones become less intense and there is less contrast between light and dark tones. In a temperate climate colours also appear to become bluer or greyer as they recede. As we have already discussed, blue is a recessive colour, so use it in the background, on its own or mixed with other colours to create a sense of depth.

Do not forget to consider the detail of the form of the individual animal in perspective. This has been dealt with in the chapter on Developing confidence, using simplified geometric shapes to give an understanding of the effect of linear perspective.

Accurate observation of your subject matter, and constant checking of one part of the drawing to another will help enormously when tackling perspective to convey scale and distance.

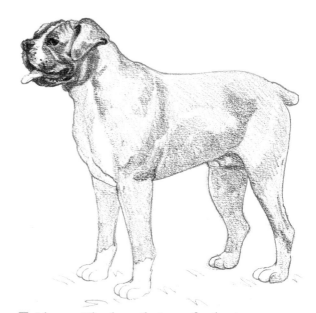

■ **Above: The legs that are furthest away appear shorter than those that are nearer. If the animal is facing towards you or is seen in a three-quarters view, the back legs will appear higher on the paper.**

TIP: *If you are not sure how big the animal in your painting should be, cut some animal shapes from paper or card in a range of sizes. and position them on the picture area to see which one is correct.*

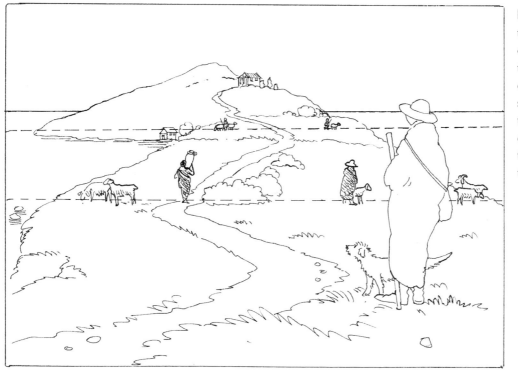

■ **Left: Ensure that the animals on one side of the painting correspond in size to those that are the same distance away on the other side of the picture.**

■ Above: Placing the ducks high up on the picture draws the eye into the painting. The converging lines at the side of the pool underline this effect.

■ Right: Sheep are different colours and tones when painted at different distances in the landscape. The colours used here were diluted for the distant sheep and landscape, with a little blue added to the wash. Don't forget to put a shadow under the animal, whatever the distance, to ensure it is firmly anchored to the ground.

WAYS OF WORKING

Making a picture that has animals as its subject, whether they are the focus or merely incidental to the composition, has its own particular considerations.

As you work, you will develop a feel for the way your interest lies in terms of subject matter and the way you convey it. Your subject can be as complex, or as simple as you wish to make it – a 'finished picture' does not always have to be elaborately worked out in terms of composition or technique.

Always keep your sketchbook to hand and develop a keen observation for the subjects that interest you, finding ways to capture an impression of the animal. My principal at art school used to quote the old adage: 'painting and drawing is 90 percent looking and 10 percent doing'. It is quite true.

If you like to work spontaneously in front of your subject, you could work outdoors directly on a watercolour painting with very little preparatory work (perhaps just an investigatory sketch of the animal and a few thumbnail versions of the composition). If you are painting in this way it is best not to attempt a large-scale painting.

Working drawings and colour studies can be made 'in the field' and used later as reference for paintings made in the studio. By doing this you give yourself the scope of painting the subject as you originally saw it, to interpret the composition in other ways, or to combine it with elements from other drawings. Photographs are another useful addition to your reference sources (but I have already warned against relying on them too heavily).

Watercolour is my preferred painting medium, but the working methods that are illustrated in the rest of this chapter can be interpreted to suit the one that you like best.

EXERCISE: *Set yourself a subject for a painting, a picture of a dog chasing a ball, for instance. Start by spending some time with the dog, observing him and getting to know him. Then try a few sketches – at this stage they do not have to be 'action' poses. Try to capture his personality, and make drawings of his features and colouring. Familiarize yourself with a dog's anatomy, noting where the joints are because these are crucial to his movement. Take several photographs including close-ups, and shots of him moving and running. Compose the picture using the sketches, your knowledge of the animal and photographs. Choose a medium that reflects the nature of the animal.*

■ **Below: I captured this image of an old rabbit fast asleep in his pen by working on the spot in pencil and watercolour.**

SKETCHING

The sketch is the *start* of the painting, it is not *the* painting – that is another, separate statement. Sketches are the first enthusiastic response to what you see. They are very immediate – infused with a sense of life and movement.

'Sketching' is a slightly misleading word. In a non-art context it is sometimes used to describe a careless approach – 'sketchy' can imply something left incomplete or done in a hurry. In my dictionary one of the definitions is 'slight' – but another is 'blueprint,' and this is the meaning I prefer.

Sometimes studies and sketches become valued as objects in themselves; for example, some of John Constable's (1776–1837) painted studies for exhibition pictures are more highly regarded than the finished works. And it is true that one can sometimes capture the rare and essential about a subject in a sketch, and lose it in the finished painting. Sketches are explorations, recording information and finding out about the subject. In a sense they are incomplete because they are not finished pieces of work, but they are important and valuable for reference.

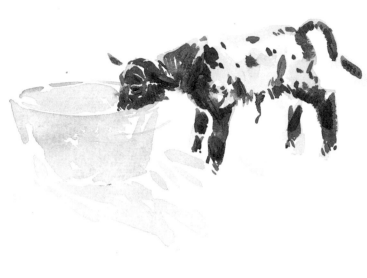

■ **Keep a sketchbook and draw anything that interests you. Even the briefest of sketches can trigger ideas and provide material for paintings.**

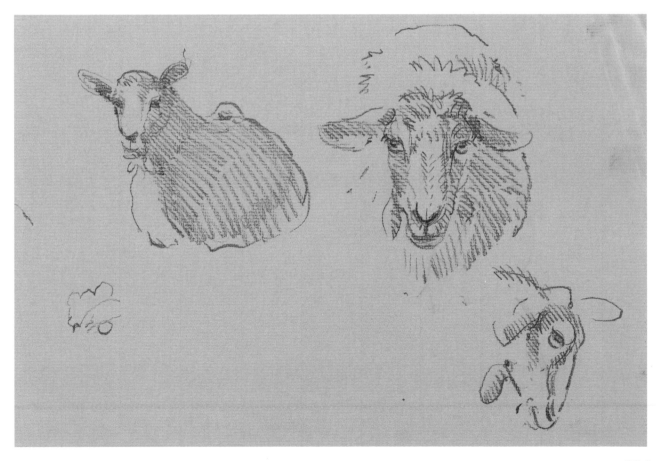

While making several sketches of the same animal you will find clues to its character. As I was making the pencil drawings of the spaniels on this page I began to build up an idea of how I wanted to paint them (see page 120–121).

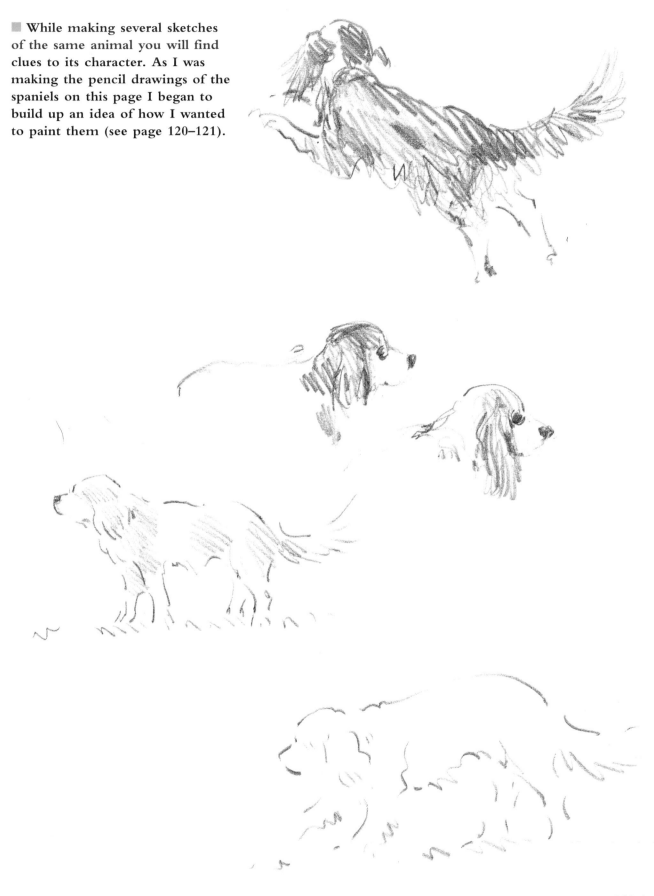

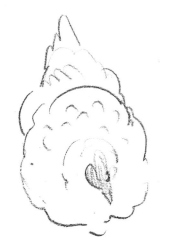

Sketching will help you to understand fully how a particular animal works – sometimes looking is not enough. I made these rapid pencil sketches of chickens, trying to capture something of their abrupt movement.

Below: some sketches capture a moment so well that they become an end in themselves.

PAINTING OUTDOORS

If you choose to work on a watercolour painting on the spot, you will need to work quickly. The light will change more quickly than you can paint, and the shadows will change as the day progresses. A good plan is to have a morning and an afternoon subject.

Mark out your painting with a medium-sized brush, using a thin solution of cobalt or burnt umber – this will disappear as you paint over it. Notice that I refer to 'marking out' rather than drawing. If you 'draw' you may produce a 'drawing' which gets coloured in, rather than a 'painting' – fine if a tinted drawing is what is required, but it is not a painting. If you feel braver using a pencil, that is all right, but be sure to mark loosely. Concentrate on locating the elements and avoid detail, then get on with painting!

Painting from light to dark, work from the back of the picture to the front (except for animals which may move away). This method of working allows you to relate your tones more effectively, ensuring that each element takes up its correct location in space. Take sheep, for example, which will appear totally different in colour depending on where they are in the landscape.

TIP: *If you are painting in the countryside you will probably be able to find a quiet and private place to work. In a busier location, if you feel nervous about drawing in public, find somewhere unobtrusive to work and keep your back to a wall or tree to avoid people looking over your shoulder. If you still feel nervous, spend more time looking than painting. Memorize shapes before you put a mark on paper – lose yourself in concentrated observation and the act of painting. Squinting helps you to simplify shapes and tones, and see more clearly – it also makes you look cross, and I find most people leave you alone.*

■ **I had to complete this snow scene with sheep fairly quickly before I got too cold. I used pastel on the watercolour to give highlights and textural interest. The sharply contrasting tone in the foreground, and the path leading into the composition, emphasize the effect of depth.**

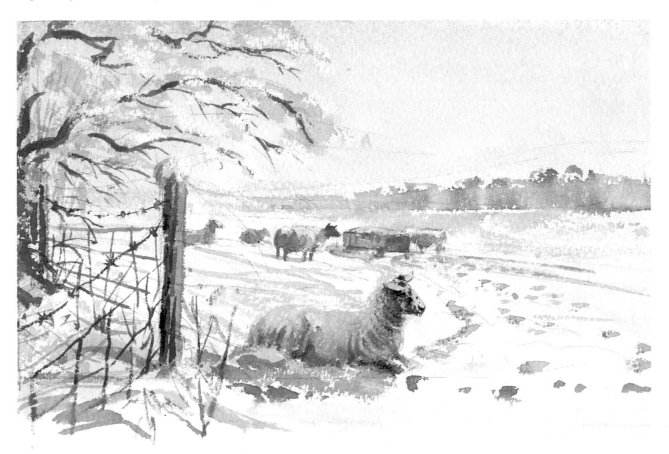

■ Right: I started this painting by laying preparatory washes over the entire support, which gave the image a wonderful luminosity: first a thin wash of gamboge yellow, and when that was dry a slightly more intense quinacridone rose. A wash of cobalt was laid for the sky.

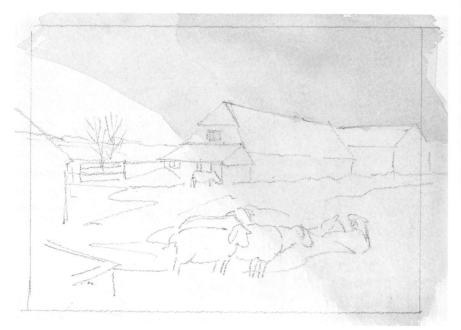

■ Below: Cobalt and ultramarine made the distant landscape recede, and suggested a slight frost. Touches of warmer colour draw the eye – a red-brown ear tag on one of the sheep, and a lighter mix on the background cow and dung heap. White coloured pencil suggests frost in the foreground.

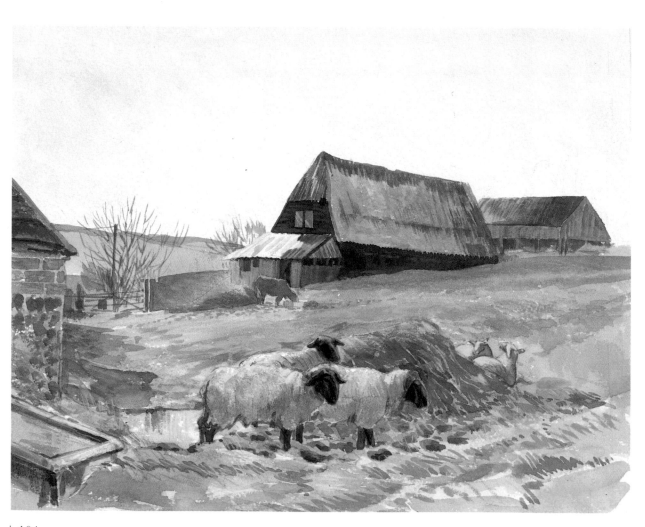

ANIMALS IN A LANDSCAPE

When painting a landscape with animals, start by sketching the animals first, in case they move away. I have sometimes been so anxious to get the landscape right that I have forgotten to draw the cows, only to find that they are no longer around!

If you are primarily a landscape painter you may occasionally want to include some animal 'furniture' in your composition, as they are a wonderful way of breathing life into a landscape. The first thing to do is decide how important the animals are to be in your painting – perhaps they will provide a focal point, designed to draw the eye of the viewer. The most important thing to remember is that your group of grazing sheep or cows should fit 'into' the landscape rather than 'onto' it. The resulting composition will then be more harmonious.

To achieve this, you could try a drawing method known as 'continuous' line drawing, in which every-thing in the picture is created with a single continuous line without taking your pencil off the paper. The painting is then completed in the usual way. This technique is sometimes set as an exercise in drawing classes, and it is a really practical system for achieving a coherent image.

> TIP: *When you are painting outside, try to get downwind of your subject – particularly if it is something wild and possibly dangerous.*

■ **Continuous line drawing is often used as an art class exercise. Use this technique to draw animals in a landscape and you will find that the painting hangs together very convincingly.**

STUDIO PAINTING

I like to work in my studio, composing paintings from material gathered beforehand. It is a way of working that has many advantages: it is useful if your time for painting is limited because of other commitments, or because the weather is changeable; it also allows you to exploit material gathered on a touring holiday, for example; and it allows time for reflection and rearranging before you commit yourself to the painting. Painting in the studio also suits people who find that painting in public makes them nervous.

Before starting, make sure that you have gathered

■ **I used these colour sketches of sheep and new-born lambs in a barn as elements of the composition for the painting on the next page. I used a limited palette of earth colours (yellow ochre, burnt umber, burnt sienna) together with indigo, french ultramarine and a little rose madder.**

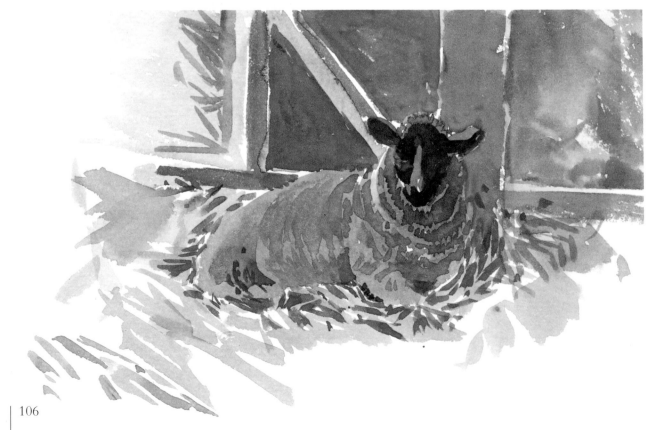

together enough reference for your painting. Working drawings or colour sketches with good notes, and back-up photographic reference are all important. As there is not the same time pressure that the outdoor painter experiences, you can take your time and try out a number of compositions before deciding on the final one. You may even decide to do more than one painting using the same elements, or bring in new subjects from other sources.

When painting in the studio, make sure that you are working in good light, ideally diffuse natural daylight. Strong sunshine and electric light will both affect colour values as you paint, but if you must paint by artificial light, use special 'daylight' bulbs.

EXERCISE *Produce a finished picture based on several detailed studies of a single subject. Place it in a suitable landscape background based on sketches and other reference material.*

With the benefit of time and plenty of well-researched reference, I was able to plan and paint this composition in the comfort of my studio. I have arranged the watchful ewe with her lambs in a triangular composition, and have focussed on their importance by leading the eye along the rails of the pen into the corner.

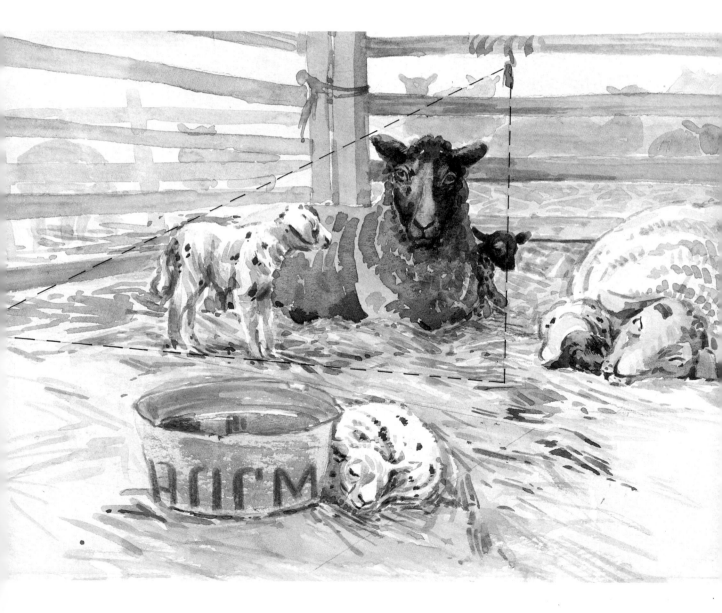

ASSEMBLED COMPOSITION

A composition can be brought together from several different sources, and this is what I decided to do to produce the painting of *Sheepdogs and Sheep in Snow* (on the next pages). The setting sun on a snowy field formed the framework for the composition; to this I added a scene I had come across some time before of a shepherd working with his two dogs.

I assembled the sketches, photographs and working drawings (some of which are shown on these pages) and selected elements that worked together to create the effect required. Remember always to back up photographic reference with a working drawing or painting, with notes of shadows and light direction, and – most importantly – written notes about colour.

TAKING COLOUR NOTES

If your descriptions of the colours are accurate and precise, you will have no trouble arriving at that colour back in the studio, and you should still be able to paint twenty paintings in twenty years' time. This doesn't mean writing 'green' for grass or 'brown' for horse. Our colour memories are notoriously inaccurate, and I certainly can't remember the subtleties within particular colour ranges unless I record them on the spot.

If you have difficulty in identifying precisely the colours you see, or if you are not sure how to mix them, try comparing them with familiar objects. I once taught this system to a student who went out and made a working drawing with comprehensive colour notes mostly based on his clothing. His colours included 'trouser green' and 'jacket brown', which were all easily replicated back in the studio. Perhaps you have a carpet that is the shade of blue you see in front of you. I often base my descriptions on fruits, herbs and vegetables, so a distant hill may be 'sage' green, a sky 'duck-egg' blue, and a horse 'liver' brown. I also say whether the colour is hard or soft – recession will soften the colour by several tones, and that should be recorded. I also note the direction of the light, the time of day, weather conditions, and if possible make a short note about the atmosphere – whether it is sombre, bright, tranquil. These notes will help you recall the scene.

■ **I made a pencil working drawing of the scene as the sun was setting, making notes of colour descriptions, the time of day and the weather, together with additional written notes about my feelings about the scene**

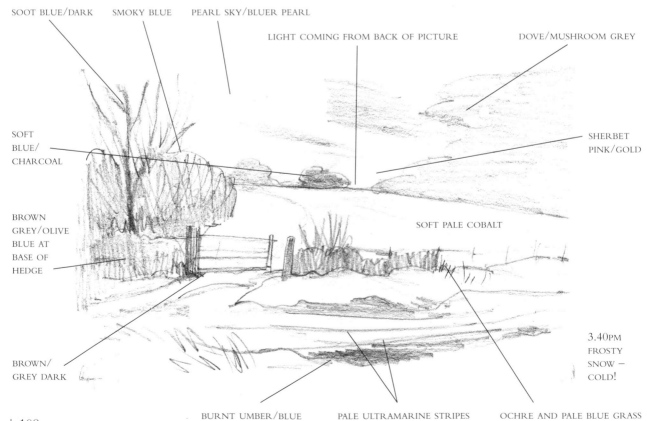

SOOT BLUE/DARK SMOKY BLUE PEARL SKY/BLUER PEARL

LIGHT COMING FROM BACK OF PICTURE DOVE/MUSHROOM GREY

SOFT BLUE/ CHARCOAL

SHERBET PINK/GOLD

BROWN GREY/OLIVE BLUE AT BASE OF HEDGE

SOFT PALE COBALT

BROWN/ GREY DARK

3.40PM FROSTY SNOW – COLD!

BURNT UMBER/BLUE PALE ULTRAMARINE STRIPES OCHRE AND PALE BLUE GRASS

Photographs of the scene taken over a short period of time gave me a record of the changing effect of the light and shadows on the composition. I also took photographs from various positions to record quickly and easily the scene from different viewpoints.

Right: I gathered reference for the drawing of the animals from different sources. In this case I wanted to study the mouth area. This lamb had died and I was able to make a study before the shepherd removed it.

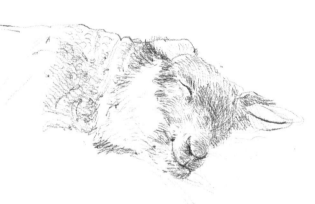

Rapid pencil sketches of the sheepdogs gave me an insight into their enthu-siastic character and their alert and stealthy action.

■ SHEEPDOGS AND SHEEP IN SNOW
I based this painting on a sunset
seen locally. The sun was setting
fast and I was fascinated by the
shapes and colours of the
shadows. I decided to make the
sky a little lighter and include a
motif I had come across
elsewhere: two dogs working with
sheep and the shepherd. One dog
was learning his trade and was
watching the older dog; he was
desperately keen to get the sheep
moving, and was only just
managing to restrain himself and
remain seated at the entrance to
the field.

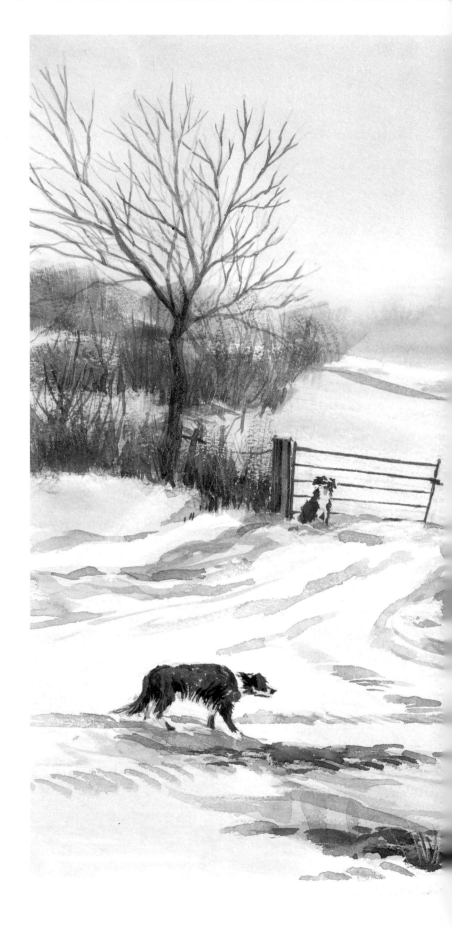

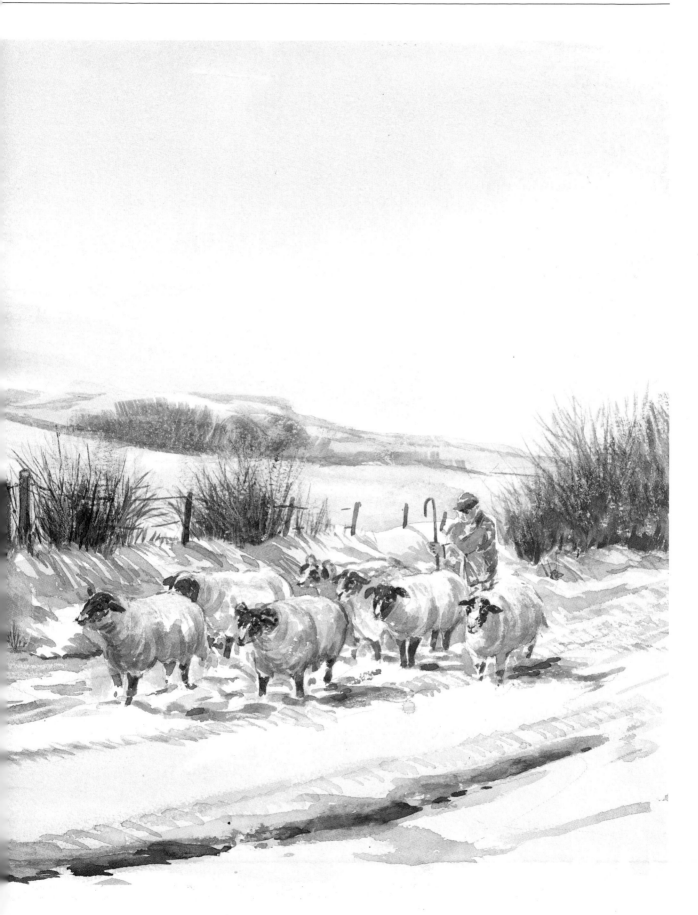

RANDOM COMPOSITION

With the invention of photography in the nineteenth century, artists became aware of the possibilities of the random, unposed composition, these instantaneous 'snaps' creating a compelling impression of immediacy. Inevitably, these photographic devices had their impact on painting: in the canvases of Edgar Degas (1834–1917) depicting race meetings, for example, subjects appear to be moving in and out of the composition and are sometimes only partly seen. But this gives the viewer a feeling of 'being there', and of movement and transition.

This was my inspiration when I decide to make a painting of the famous *Appleby Horse Fair* which takes place each year in Cumbria, where gypsies and travelling people gather to trade horses.

I assembled my material in the form of photographs and copious sketches, trying to capture the intense activity of the washing and grooming of the horses in the river before they were sold.

Back in my studio I put together the elements of the scene to give the composition a deliberate impression of a snapshot spontaneity, a random quality which gives the impression of immediacy.

■ **I made these sketches at the horse fair with a soft pencil, working quickly to capture gestures and movement.**

This was one of many photographs that I took at the fair, enabling me to record a multitude of detail in an instant. Framing up different scenes in the camera's viewfinder also helped me to get ideas for composition.

■ APPLEBY HORSE FAIR
I wanted to capture a 'moment' of the action at the busy fair in this picture. I selected elements from the sketches and photographs taken at the time and focused on the central scene of the photograph on the previous page (changing and simplifying much of the detail). The horse and boy at the bottom of the picture appear to be moving into the composition, giving it an immediacy and leading the eye into the action.

I used paper with a slightly rough texture, and began the painting as a watercolour. I then worked over it with pastel to complete the painting.

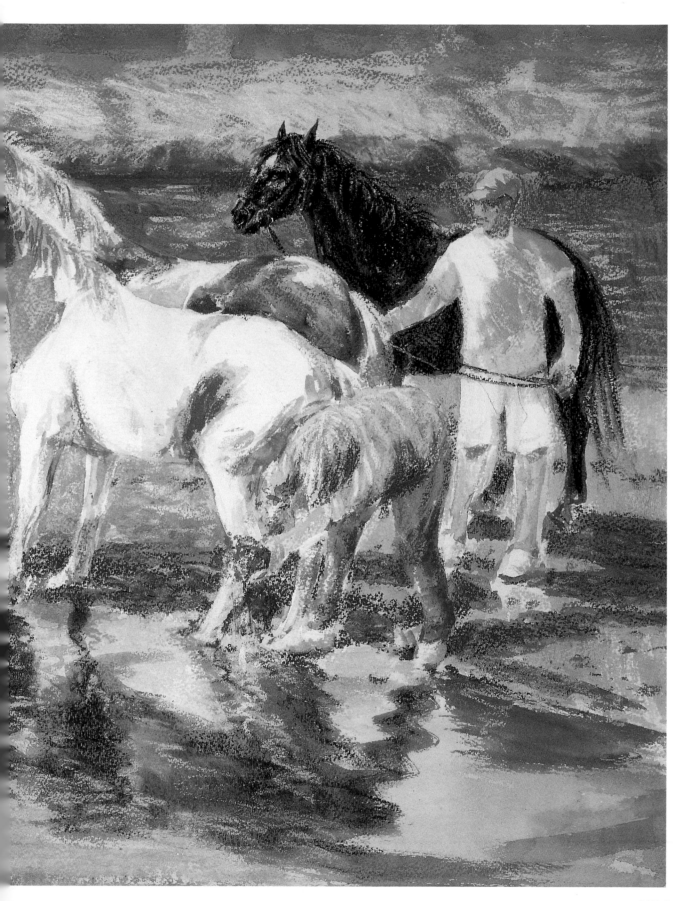

PLAYING WITH SCALE

Imaginative pictures can be made by altering the scale of your subjects. In this example I placed two tiny Shetland foals amongst colourful grass and daisies. By exaggerating the scale of the foliage in relation to the ponies, it gives the impression of fairy creatures inhabiting a fantastic land.

■ **Right: Pencil sketches of a little foal capture characteristic poses, and help to give an understanding of the proportions of these small ponies.**

■ **Above: I began to work on colour studies of the ponies, concentrating on the texture of the hair and the features of the head.**

■ **Above right: Using Fabriano cold-pressed paper and two brushes (No. 2 squirrel and a medium-sized pointed synthetic brush) I made colour studies, also of the grass and daisies, adding the mushroom to emphasize scale.**

■ Opposite: The painting was worked in the following way:
Hooker's green was washed over the area to be covered with vegetation, except for the daisies. When that was dry, a darker wash of cobalt blue and Hooker's green was added to suggest shadow. I left lines of the pale first wash to stand for the nearest grass stems. Finally, a mix of Hooker's green and Payne's grey was used for the darker parts of the undergrowth, leaving some of the blue mid-tone showing.

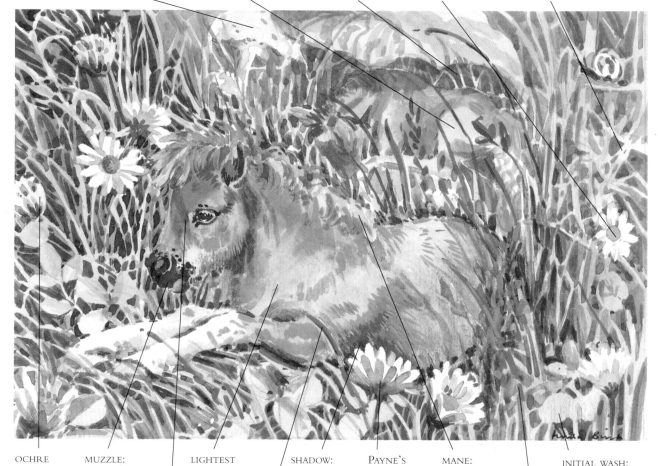

PALE OCHRE +
BURNT UMBER,
WITH COBALT BLUE
IN THE SHADOW

PALER WASH OF
COLOURS ON
THE FRONT OF
THE FOAL

DEEPER TONE:
HOOKER'S
GREEN +
PAYNE'S GREY

GAMBOGE

INTERMEDIATE WASH: COBALT
BLUE AND A LITTLE HOOKER'S
GREEN. MORE COBALT ADDED
IN THE DISTANCE

OCHRE
WASH +
BURNT
UMBER

MUZZLE:
PAYNE'S GREY +
FRENCH
ULTRAMARINE

LIGHTEST
TONE: INITIAL
WASH OF
YELLOW OCHRE
+ VERMILION

SHADOW:
BURNT
UMBER +
COBALT BLUE

PAYNE'S
GREY +
FRENCH
ULTRAMRINE

MANE:
YELLOW
OCHRE WITH
A TOUCH OF
VERMILION.
SHADOWS:
BURNT
UMBER +
COBALT BLUE

INITIAL WASH:
HOOKER'S
GREEN OVER ALL
THE GRASS AREA
AND LEAVES

MID-TONE:
YELLOW
OCHRE +
VERMILION

GREY SHADOW:
FRENCH
ULTRAMARINE +
BURNT UMBER

YELLOW OCHRE +
VERMILION +
WHITE
GOUACHE

The white of the paper stood for the light parts of the daisies, with a pale wash of Payne's grey and French ultramarine for the daisies in shadow. For the mushroom I used a pale wash of yellow ochre and burnt umber, with cobalt blue for the shadow.

A watery wash of yellow ochre and vermilion red was applied over the foal, except for the muzzle. A paler wash was used for the foal behind, to suggest recession. Before this was completely dry I added a stronger, redder mix for the mid-tone on the coat; this bled into the still-damp wash, creating areas of tone with soft edges.

When it was completely dry, I used mixes of burnt umber and french ultramarine for the shadows – some were bluer and cooler, some browner and warmer. For the muzzle I used a light blue mixed from Payne's grey and french ultramarine; a stronger mix was used for the shadows. White gouache was used to provide touches of light.

PORTRAITS

For portraits of domestic pets you need to make special 'sitting' arrangements: like people, most animals don't like being stared at, and they will usually shift position many times during your session. Patience is a great asset for the animal artist. Use a large sheet of paper to make preliminary drawings. If the animal moves, start another drawing, and return to the first poses as and when the animal does; you will then have plenty of choice for the finished painting. Bribery with food often works, placed so that the animal takes up the pose you need. You might have to put the food near the animal's face and nearer your eye level. Other distractions for the animal include television and another person, particularly useful as I find that my models often want to share the drawing pad with me! Try not to sit too close to the model – it is much easier to observe clearly from a distance of at least a metre.

With larger animals such as horses you should get to know as much about the animal as you can. All animals have unique personalities, and if you want to lift your portrait from a mere record of the animal to a unique study of a singular character you need to know as much as possible. Horses have a quirky sense of humour and owners will always tell you about an animal's particular idiosyncrasies and traits.

Decide on the most suitable pose. A lively spaniel will look better running than sitting down (see overleaf), while a dignified elderly cat will probably be best depicted in a seated pose.

■ **My eleven-month-old kitten Guy is never still for very long – except when he is cleaning himself or sleeping. I wanted to describe his lively character, and felt that a single pose would not do him justice. I managed to do all these poses on a single sheet. If you are worried about this, try doing several poses on separate sheets; mount them separately but frame them together in a single frame. I used rag watercolour paper which is soft, a large squirrel brush and indigo, french ultramarine, vermilion red and gamboge yellow as my colours.**

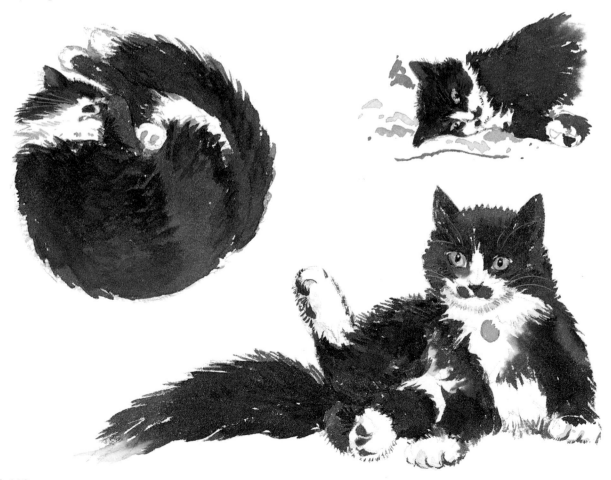

Sherbet the ram belongs to some friends of mine. An orphan, he was hand-reared and is a family pet and a great character. I wanted to capture his personality but felt a formal portrait would be too static. I started with a pencil study of his head – he had obligingly stuck it through the fence to watch me and stayed there long enough for me to start a watercolour. Back in the studio I was pleased to find that I had caught the spirit of Sherbet. I considered that if I started another painting I risked losing the vitality of the original, so instead I worked up the original watercolour, using pen and ink to describe his craggy quality. I indicated the surroundings lightly to focus attention on the head.

The materials used were 94lb (200gsm) cartridge paper, a 2B pencil, and five water-colours: raw sienna, indigo, burnt umber, cobalt and french ultramarine. Texture was added with a dip pen with a drawing nib, and a strong solution of burnt umber watercolour instead of ink. In places I diluted it to achieve a paler shade. For the texture on the eyebrows I used crisp touches of white coloured pencil applied over the watercolour.

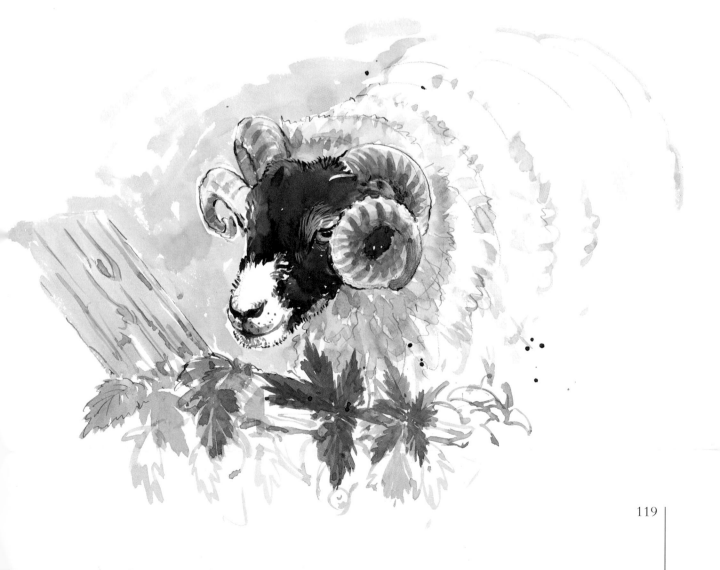

■ SPANIELS IN SNOW

In an attempt to create something different from the traditional portrait in which the animal stares out at the viewer, I showed this particular dog hunting with its companions – a setting which reflected its lively character. I worked from pencil sketches (see p103). For the painting I used Not Saunders watercolour paper. I used a wet-on-wet technique for the background, and dry-brush in the foreground. I added further texture in the foreground by scratching with a sharp craft knife, and a dry watercolour pencil was used to create texture in the fur. My palette was: french ultramarine, burnt umber, burnt sienna, yellow ochre and orange.

FINDING YOUR SUBJECTS

What do you do if you like painting elephants and live in a city? This can be difficult. However, some cities have zoos and so elephants may not be as elusive as you think. And what if you are a landscape painter who also likes to paint animals and again, you live in the city? You need to go to the country to find farm and wild animals, but it is surprising what you can find right under your nose. I was in Paris once and wanted to record my impressions of the city. Buildings aren't my greatest interest, and one afternoon after a shower of rain I glanced out of my hotel window and saw a great many dogs being paraded up and down the boulevard under early April trees. Paris is a good place for dogs and there are a great many breeds, so I produced a large oil painting of this scene which best captured my impressions of Paris in April! Similarly, Venice is full of cats and London of pigeons – if you look hard enough you will find plenty of animal life in any urban location.

Pet shops and town farms are other sources for locating animal subjects in built-up areas. Your own domestic pet could make a good subject, and if you do not have one, you might consider asking a friend or neighbour to 'borrow' an animal. The range of animals kept at home can be quite exotic (with reptiles rapidly increasing in popularity). Television programmes can also provide a surprisingly rich, and convenient, source of material.

In rural areas the scope is a lot wider. Agricultural shows, livestock markets and animal shows provide subjects with plenty of action for the animal artist. Farms offer a rich source of subjects, both in the farmyard and in the fields, but first ask the farmer's permission (an offer of a drawing might be a welcome gesture). Wildlife parks can give you the opportunity of seeing non-native wild animals in a relatively natural habitat.

■ BOULEVARD IN PARIS
Animals exist in every city. In Paris, I looked out of my hotel window one April afternoon, just after a shower of rain, and saw a procession of people walking their dogs, resulting in this oil painting.

PAINTING WILDLIFE

Painting wildlife can seem daunting, although I know artists prepared to face wild bears and even to draw under water. There are several approaches that can help you to achieve what you want. Most wildlife is shy and elusive, and a lot of animals are active at dawn or dusk when the light is poor and it isn't easy to draw. However, you need to work on site to get the 'feel' of the habitat, even if you don't glimpse your quarry. Record the area by making drawings and colour notes, and taking photographs. Pay particular attention to the light source, because the light and shadows on the animal in your final painting must be consistent. If your subject is small – a mouse, for example – record everything from a lower eye-level.

If you are lucky enough to see your subject, record it as quickly and quietly as you can, but what if you don't actually see your animal? There are several solutions to this problem.

You could look for a good photograph, although remember that photographs are of limited value. You might be able to find the animal you want to paint in a zoo. If so, draw it in as many positions as possible –

even if there are only one or two specimens, you can create a whole group based on your sketches.

A third option is to look for stuffed specimens in a museum or natural history collection. If you cultivate a good relationship with the curator you may be allowed to sit and draw in the collection, or even borrow smaller specimens. Stuffed animals are an excellent way of making a close study of details, and you can do it at your leisure. The knowledge gained will help you to understand the live animal when you see it.

It is also possible to paint from scale models, a time-honoured method used by Thomas Gainsborough (1727–1788) among others. Artists constructed miniature barns and other landscape features and painted from these in their studios. I am not suggesting you go that far, but you could use good quality model animals. I still have the farm set I played with as a child and the sheep, pigs and cows are accurately modelled. Place the models in a good directional light, at the right height for the eye level you want to view them from. You can then make observed drawings from any position.

■ **This elusive night bird, the owl, was painted from a stuffed specimen and then assembled with the background. In order to create a more natural pose I placed the owl above my eye level, as though I was seeing it in the cleft of a tree. I started by laying a wash of light yellow ink (more brilliant in hue than watercolour). When that was dry I added a pale wash of quinacridone rose (avoiding the moon) and then a wash of cobalt blue watercolour.**

The bird was painted in watercolour using yellow ochre, sepia, burnt umber and burnt sienna, with french ultramarine and indigo. The texture of the feathers and the soft 'clouded' tones were created with coloured pencils in buff, white and grey.

CHAPTER 6

Questions and answers

Q: How do I get a sense of 'life' in my depictions of animals?

A: Life is about movement – even at rest an animal is never quite still. To capture that elusive 'living' quality, you must take every opportunity to observe animals closely. Study their stance and the way they move, and become familiar with their typical standing or moving positions. Notice, for example, that an animal rarely stands with all four legs in the same position – one or two are always set a little forward. Note the ways in which animals of a particular species sit or stand. This knowledge will be invaluable when you begin to draw and will allow you to imbue your art with energy and life; this is especially important if you have to work from photographs. These often distort and flatten form, but prior knowledge will help you to make sense of what you see in the photograph.

One of the most important features of close-up or 'portrait' study is the eyes. The highlights are critical – if clumsily rendered or mistakenly placed, they will definitely kill the subject!

Q: How do I get my sheep or other animal to stay in the distance?

A: This is a question about tone and scale *(see* aerial recession and tone, page 96). To ascertain scale you should try to relate the animal to something else at the same distance – a fence-post or a tree, for example. Objects become lighter and lose their tonal contrasts as they recede into the distance, so your sheep will become lighter in colour and tone. Detail such as eyes, noses and

mouths will not be visible, while feet are likely to be hidden in grass, or lost in the folds of land between. Shadows are crucial. They anchor the subjects to the ground and prevent them from appearing to float in the air.

Q: If animals are moving, what should I do to convey the sense of movement. Should I leave anything out?

A: Study Chapter 4: Capturing movement. To convey an impression of movement you need to be able to identify the essential part of a particular movement. To find it, you must watch an animal carefully and note what action you remember – *that* is what you need to draw or paint. Try this exercise with a video of, for example, a race meeting. Study a galloping horse, concentrate and commit the most significant movement to memory. Then replay the video and see if you were correct.

To paint movement you need to edit out the inessentials, and to do this effectively you need to understand how the eye sees things: this is not the same as a camera. In the act of seeing, the eye tends to focus on salient objects and is only aware of the rest. What we focus on will depend on colour, contrast or shape. For example, a bunch of flowers consisting of a large yellow rose surrounded by deep green foliage and soft blue forget-me-nots would probably be registered by the eye in the following order: first the yellow rose, because yellow is a salient colour and the flower has a strong shape. The dark foliage provides a strong contrast and would be seen next. Because the forget-me-nots are small and blue and therefore

recessive, they would probably be noticed last. To recreate this reality, you could paint the rose and its surroundings in detail, and the other flowers more loosely and impressionistically.

In a horse-race, a bright chestnut horse nearest the camera would be a salient object. The bright highlights would catch the eye and should be put in carefully, while the darker blur of its galloping legs would be less detailed.

Watch for clues to movement. Elements such as streaming manes and tails increase the impression of speed. Sometimes the background appears slightly blurred and this, too, can add to the effect of movement.

Q: How can I get an animal to pose?

A: You can't! The only way to get an animal in the pose you want is patience. When you are sketching, start a series of positions on a large sheet of paper. The animal will eventually move back into the position you want, and in the meantime you will have created a collection of poses to choose from.

You could also try feeding the animal titbits in the position and at the distance you want. Photographs can be useful, especially if you have a dog which will pose for a few seconds for you. Make plenty of back-up sketches so that you don't rely on the photograph alone.

Q: How can I get close enough to an animal to study it and get detail?

A: Not easily, unless it is very obliging or you are very lucky. Wild animals present particular problems and you will need a great deal of

patience. In wild animal sanctuaries you can sometimes see foxes, birds and deer close up. A camera with a long lens is invaluable, but again, don't be tempted to rely on it as your only reference. Stuffed animals are also useful. Take the opportunity to study them in a museum of wildlife and you will become familiar with form and texture.

Q: What about backgrounds, what is the best one for my animal picture?

A: The one you saw it against is usually the best – although this is not true of stuffed animals. If you are making a painting based on a stuffed animal you should, if possible, visit the animal's habitat and paint on site if possible. In a cat portrait you may have very little background in the painting, and in this case you could try mixing together all the colours that you used for the cat – the result will probably be a mud colour (or neutral)! If you use that for the background, it will inevitably have a colour relationship to the subject. Always check to see whether the background needs to be light or dark in relation to the subject to achieve maximum tonal contrast.

Q: I want to do pet portraits. How do I go about it?

A: When friends know that you paint, sooner or later someone is sure to ask if you could paint their cat or dog. People often want a memento of a pet that has died. If pets are not your speciality, say so immediately and avoid a lot of problems! If, however, you are interested in painting pet portraits, then by all means go ahead.

Start by establishing what exactly your friend (or client) wants, and see if that matches what you know you

can do. Then you should agree a price. It is important that you always make a charge – unless the picture is a gift – otherwise you will spend the rest of your life painting dogs and cats for nothing, and this is bad practice for several reasons. It makes life difficult for fellow artists who have to charge for their work, and it undervalues what you do. Most people, even friends, are usually quite happy to pay.

If it is a professional commission you must also agree a rejection fee – this figure is usually less than the full fee, and covers you for the time spent if the picture does not suit the client. This protects the artist from the whims of an exacting or unreasonable client – unfortunately they do exist. However, if you have discussed the brief thoroughly with the client, then the commission should be straightforward.

See the chapter on Making pictures for the method of working. If you have been asked to paint an animal that has died, try to obtain living reference by studying similar animals. Don't rely solely on snapshots taken when the animal was alive. Check the anatomy of the animal in a book – if you are serious about animal painting, a book on animal anatomy will be an essential part of your library.

If the animal is alive you could offer the client a sheet of studies done over a period of time. That will often capture the character of the animal far more effectively than a single picture. If you are worried that a sheet might include some failures, you could do the studies on separate sheets and select the best. These could be displayed as a composite in a window mount and framed.

Q: I cannot get out to draw and paint. How can I paint farm and field animals, or wild animals, indoors?

A: This is a problem for some painters, especially if they are housebound. If you have sketches made out of doors at some other time, you can use those. Otherwise use photographs, but check the section on photographs in the Making pictures chapter. Use accurate model animals (*see* p123). If you have just one sheep, you can make it into a flock by altering its position for each drawing. Be sure to draw it at the right eye level: that is, nearly on your eye level if you are assuming a seated viewpoint, or slightly below eye level if painting as though from a standing position.

Q: How can I get my scale right when placing animals in a landscape?

A: Try to relate the animal to something near it in the landscape, for example a tree or a bush. As we have said already regarding scale, imagine the animal standing by a fence-post, for example, and think how the relationship of post to animal would appear. If you are not confident about getting it right, try drawing it lightly with a soft pencil (2B or softer) which can be erased, or cut out small pieces of paper; if the scale doesn't look right you can erase the pencil line and try again, or cut out another piece of paper. If an animal which is darker than white is in the distance, start by painting it light grey. When it is dry you can apply the actual colour on top. This will 'place' the animal in position at that distance.

Q: How do I get the colouring of my animals accurate?

A: There is no set rule or 'trick' for this. Look carefully at all the colours you see, then analyse those needed to make a particular mix. Remember that colours become

softer and more grey-blue as they recede into the distance.

Be careful not to make your whites dead white, because all whites take on a hint of other colours – often they look cream, for example, especially if the sun is shining. A pale wash of yellow ochre or raw sienna produces a good ivory – a warmer white. Introduce some blue into shadows, particularly if the light is warm in colour. Because blue is recessive it will suggest a plane turning from the light, and therefore depth. I often see brown used as a shadow colour. This does not work if the brown is too warm in hue because red and yellow are components of brown and will try to come forward in the picture, tipping the shadow towards the viewer. If you need to use brown in shadows, use a little blue as well, to 'knock it back'.

It is not generally considered good practice to mix more than three colours together – certainly watercolours can become very muddy if over-mixed. Useful colours for painting animals would be: yellow ochre, raw sienna, light red, vermilion, alizarin red (crimson), burnt umber, raw umber, burnt sienna, french ultramarine, cobalt and indigo.

Q: What is the most suitable medium in which to do fur?

A: It has to be the medium you are most used to, since you will handle it better. When I am working in watercolour (my preferred medium) I sometimes find it useful to add texture when it is dry, using a dry coloured pencil. This adds a roughness which renders texture well. Adding texture in another medium can enhance a drawing or painting and solve a problem – but be careful not to obscure the original medium.

Q. Are some animals notoriously difficult to draw and paint? If a landscape painter wants to add animals as landscape 'furniture', what would be the easiest ones to use?

A: The most 'difficult' animals are probably the ones you don't like! I am frightened of snakes but when faced with drawing one in a pet store many years ago, I regarded it as a challenge. It was a wonderful model and never moved during the two hours I drew it.

Birds and busy animals such as mice and gerbils can be tricky, as they are never still. You may need to use photographic reference, but do combine it with direct observation. Working out just what is happening when an animal moves is difficult.

Patterned animals are interesting to paint, but if you haven't tackled these before I would suggest that you start with a Friesian cow rather than a tiger! A Friesian is a gift for the painter because the way the pattern folds around the animal actually reveals the form. Remember to include light and dark in your black and white to allow for shadows and highlights.

Landscape painters will find cows to be useful additions to a picture. Try a group (three works better than two or four) in the middle distance, to give a feeling of tranquillity in a scene. If you want to include animals in a landscape, pick those which contrast tonally with the ground; this makes them easier to see, and contributes a sense of pattern and composition to the picture as a whole.

Remember that as you progress from the middle distance back into the picture, features such as feet and facial details become indistinct, as in reality, objects in the distance become increasingly difficult to see.

Q. Which of the painters of the past should I look at to find examples of good animal painting?

A: There are so many places you could look for inspiration. The cave paintings of Lascaux (18,000BC) in France have a marvellous sense of vitality, while the oriental painters produced exquisite watercolours of birds and animals, and narrative 'scroll' paintings of noblemen and warriors and their horses. You should also look at Leonardo da Vinci's (1452–1579) studies of animals, George Stubbs's (1724–1806) horses and dogs (in particular his wonderful engravings of horse anatomy), William Hogarth's (1697–1764) dogs and his evil-intentioned cat in *The Graham Family*. Other important animal artists and their most notable subjects include Thomas Bewick's (1753–1828) birds, Théodore Géricault's (1791–1824) horses, Rosa Bonheur's (1822–99) horses, Edgar Degas' (1834–1917) horses, Sir Edwin Landseer's (1802–73) horses, dogs and deer, Theophile Steinlen's (1859–1923) cats, Alfred Munnings' (1878–1959) horses, Laura Knight's (1877–1970) horses, Gwen John's (1876–1939) cats, Joseph Crawhall's (1861–1913) animals and Charles Tunnicliffe's (1901–79) animals and birds. Beatrix Potter (1866–1943) was a children's illustrator, and her wonderfully accurate drawings of mice and cats and other animals are well worth studying. You should also look at the work of Henri Rousseau (1844–1910) and at Pablo Picasso's (1881–1973) *Boy with a Dove*, his screaming horse in *Guernica*, and his funny series of drawings changing a bull into a piece of string.

Conclusion

In this book I have shown you how to approach animal drawing and painting by developing your confidence through simple construction techniques. I have also demonstrated how to use a variety of tools to achieve texture and character in your drawing and painting. I hope you now have the knowledge and ability to capture that most essential (and elusive) of animal qualities – movement. I hope too that you will be able to lift animal portraiture from a mere record of features to a characterful portrayal of a singular personality, and that if you are a landscape painter you will never be afraid of painting a herd of cows into your picture again! These skills require observation, patience and confidence, together with a liking of your subject. Enjoy what you do and don't worry about making mistakes – that is how you learn.

Did you ever gaze in awe at a painting, responding to something you were personally affected by? Your next thought was probably 'I could never paint that!' Wrong – as we are all capable of a lot more than we think. Rather like an iceberg, we use only one seventh of our potential ability, and the rest is unused for a variety of reasons, usually lack of confidence, together with lack of application. We may not all become Rembrandts but we tend to dismiss our best qualities, believing ourselves not to possess the talents seen in others. As long as you are realistic about your attitude to learning, strive always to give the best to your work, and above all enjoy it, you will make great strides in your painting. 'That which we admire lies deep inside us too'. Why not realize it?

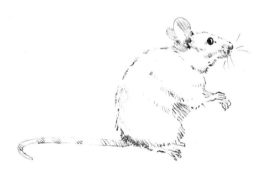

ACKNOWLEDGEMENTS

My thanks to the following:
Parsonage Farm Rural Heritage Centre, Elham, Kent; Hilary Towler at the
Durham Teachers Resource Centre, Darlington; Betty Elliot's family and
animals; The Anderson family of Friarside Farm, Wolsingham, Co. Durham;
Eleanor and Mary at Wolsingham Library, Co. Durham; Pamela Bryan;
My painting students past and present. My family, and most of all my husband
Trevor Pitt, without whose encouragement this might not have happened.

action, animals in, 87–9
aerial recession, 96
anatomy, 39–41

badgers, 47
birds, 50–3, 90–1; chickens and
 chicks, 20, 51, 74, 75, 91, 100,
 102; features, 50, 52, 53, 72–5;
 wild species, 11, 27, 50, 53,
 72–5, 123
brushes, 22

cats and kittens, 10, 14, 21, 33, 47,
 66, 83, 118; ears, 46; eyes, 42,
 84; tabby, 27
Cézanne, Paul, 31
character of animals, 76–9
charcoal, 10, 57
choosing materials, 28
colour, 25, 61; arranging, 95;
 notes on, 108
coloured pencils, 10–11, 58–9
colour wheel, 25–6
composition, 92–5; assembled,
 108–11; random, 112–15
Constable, John, 99
cows, 12, 47, 62, 67, 76, 84, 105;
 ears, 46; eyes, 84; geometric
 shape, 32; short hair of, 56; three
 great divisions, 36

deer, 47, 79
Degas, Edgar, 112
dogs, 27, 47, 61–3, 79, 85;
 geometric shapes, 31, 33; in
 action, 87; on different papers,
 24; painting, 65; proportions, 35;
 three great divisions, 36; types,
 86, 101, 110, 120
domestic models, 83, 91
donkeys, 8
drawing paper, 22
dry-brush technique, 65, 66

ears, 46
edges, 'lost' and 'found', 89
elephants, 8, 28–9, 57
empathy, 76
expressive line and brushwork, 78,
 85–6
eyes, birds, 52; mammals, 42–3,
 49, 84

feathers, 72–5
feet, 47, 53
felt-tip pens, 13–14
focal points, 94
form, 81

'four key points', 95
fur, 54, 55

geometric shapes, 30, 31–3, 81
goats, 55, 78, 84
gorillas, 15, 64
gouache, 19
graphite pencils, 8–9

hair, 55; long, 63–7; short, 54,
 56–62
herbivores, 77
hides, 57
horses and ponies, 23, 27, 47, 55,
 58–9, 65, 66, 69, 77, 81, 85; at
 Appleby fair, 112–15; dry-brush
 technique, 65; ears, 46; foals, 48;
 geometric shapes, 32; in action,
 87–9; in expressive lines, 85, 86;
 in watersoluble pencil, 9; piebald,
 69; proportions, 34; three great
 divisions, 36
hot-pressed paper, 23

jars, 22

kittens see cats and kittens

lambs see sheep and lambs
landscape, animals in, 105
Lascaux, 80
light and shadow, 55, 97
line drawing, 'continuous', 105
lions, 10

masking fluid, 18
mice, 8, 28, 57, 58
mouths, 44–5
Muybridge, Eadweard, 80

noses, 44–5
Not (cold-pressed) paper, 23

observation, 76–7
oil painting, 122
oil pastels, 21
outdoors, painting, 103–5

palettes, 22
paper, 22–4
pastels, 20–1, 67
patterned coats, 68–71
pen and ink, 12–13, 65
pencil, long hair in, 63–4; short hair
 in, 56–7 see also coloured pencils;
 graphite pencils
personality, 84
perspective, 32, 96–7

pets see domestic models
photographs, 80, 123
pigs, 31, 36, 37, 45, 58, 78, 85
placing, 94
ponies see horses and ponies
portraits, 118–21
poses, catching, 82
primary colours, 25
proportion, 34–5

rabbits, 60, 76, 77, 86, 98;
 hair growth, 55

scale models, 123
scale, playing with, 116–17
scales, reptile, 54, 55, 71
scraperboard, 15
seals, 18
Seurat, Georges, 10
sfumato tones, 9
shadow see light and shadow
sheep and lambs, 11, 13, 14, 17, 66,
 82, 97, 99, 103, 104, 106, 107,
 109, 111; ears, 46; eyes, 84;
 geometric shape, 31; ram, 119;
 three great divisions, 37
silhouettes, 38, 90
skeletons, 39–40
sketchbooks, 22
sketching, 9, 99–102
skulls, 39–41, 84
studio painting, 106–7
stuffed animals, 123
subjects, finding, 122

three great divisions, 36–7, 81
tigers, 15, 20, 70
tone arrangement, 95
Tunnicliffe, Charles, 15

viewfinders, 92
visual memory, training, 78–9, 89

watercolour crayons, 12; paper,
 22–4; pencils, 11, 58
watercolours, 16–18; long hair in,
 65; patterned coats in, 68–71;
 short hair in, 60–2
watersoluble pencils, 9, 11
wax resist, 19
ways of working, 98
wet-on-wet technique, 60, 61
wildlife painting, 123
wool, 54

young animals, 48–9

zebras, 18, 46